IMAGES
*of America*

# SYOSSET PEOPLE
# AND PLACES

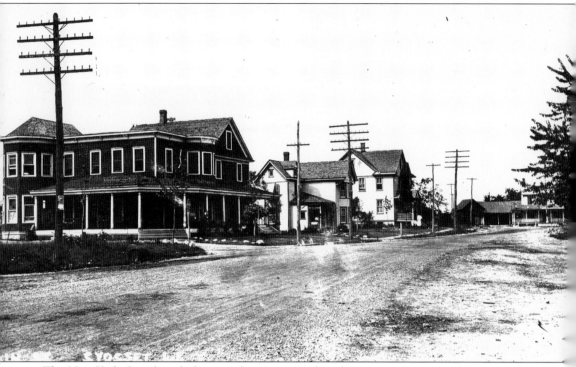

The New York City–based photographer George Edward Van Sise (1873–1965) captured this view of Syosset's main street, looking north, around 1913. Spreer's Hotel is the first building in the foreground on the left. Moritz "Yanke" Spreer (1868–1937) was the owner. The building in the background is Lang's Syosset Hotel, on the triangle between Oyster Bay Road and Brookville Road (later Cold Spring Road). (Courtesy of Michael Mark.)

*On the cover*: Please see page 78. (Author's collection.)

IMAGES
*of America*

# SYOSSET PEOPLE AND PLACES

John Delin

ARCADIA
PUBLISHING

Published by Arcadia Publishing
Charleston SC, Chicago IL, Portsmouth NH, San Francisco CA

Printed in the United States of America

Library of Congress Catalog Card Number: 2008923563

For all general information contact Arcadia Publishing at:
Telephone 843-853-2070
Fax 843-853-0044
E-mail sales@arcadiapublishing.com
For customer service and orders:
Toll-Free 1-888-313-2665

Visit us on the Internet at www.arcadiapublishing.com

*Syosset People and Places* is dedicated in loving memory to my dear friend and colleague, Pamela Boslet Buskin (1945–2006). She grew up in Syosset and graduated from Syosset High School in 1963. She was a poet, writer, editor, and co-owner with me of several nonprofit Web sites. She had a large collection of memorabilia and photographs of Syosset and its people, many of which I inherited and have displayed in this volume. (Author's collection.)

# CONTENTS

# ACKNOWLEDGMENTS

Rebekah Collinsworth, my editor, gave me expert guidance and support. I am grateful to Tom Montalbano, author of *Syosset* in the Images of America series. He encouraged me to write this book, supplied historical details when necessary, and gave me advice when I asked. I used his fine work for reference. I also referred to Patricia Tunison's *Looking Back on Syosset* and Raymond and Judy Spinzia's *Long Island's Prominent North Shore Families: Their Estates and Their Country Homes, Volumes I and II*. I thank Raymond Spinzia, and also Tom Kuehhas, director of the Oyster Bay Historical Society, for supplying information on the area estates.

I especially thank my classmate Ronald Burckley for providing the photographs of the federal landmark Schenck-Mann-Burckley home. Burckley also furnished important facts concerning the edifice.

Richard Jay Hutto, author and son-in-law of the late Anne Martin, granddaughter of Robert E. Tod, helped me a great deal in my discussion of Thistleton, the Tod estate, as did Caroline Nowak Zgutowicz, daughter of the estate's superintendent, Thomas Nowak, and Lois Ann Greenway Helser, granddaughter of John Greenway, the estate's huntsman.

I am indebted to Florence Kwiatkowski Sendrowski, Diane Oley, and Jan and Maureen McAuliffe Smith for contributing images and the background thereof.

Thanks to Liz Burke, Patrick Judge, and James "Mootsie" Thomas for help with my chapter on the volunteer fire department and to Peter Logan, Jericho Water District's superintendent, for information on Syosset's water tower. Thanks to Rick Fox of the Syosset Public Library who guided me through its local history room.

Needed details were furnished by Caren Haas Ballantine, Ronald Berg, Tom Bolk, Mel Frankel, Richard Glueck, Elaine Hammond, Sandi Gay Heimbach, Virginia Budd Vail Hofstad, Dan and Tim Horton, Eva Sweeny Mancuso, Andrea Anderson McDonald, Joyce Boccafola Michels, Christine Irish Morisco, Sally Anne Lynch, Maureen O'Brien, Shirlee Sarver, Kathleen Tracy, B. A. Van Sise, Madeleine Zeoli Weintraub, Gary Zabel, and Jane Ziegler. Many others, cited within, provided images.

John Ruggiero gave me valued technical assistance.

Pamela Boslet Buskin would have coauthored this book had she lived. Thank you, Pam. I have done my best. Thanks also to her husband, John Buskin, for his help.

Finally thanks to my wife, Janis, for her loving support and patience.

# INTRODUCTION

To new residents, Syosset is home, a vibrant, ever-changing community. To others, Syosset exists only in memories. To some, Syosset includes home and memories. To all, I present our town's history in rare photographs and postcards with commentary based on written accounts, census records, old maps, documents, interviews, and my extensive research and personal experience.

Fortunately many families have not only saved their precious memories in photographs and memorabilia but have also made them available to historians for posterity. We are fortunate to be able to preserve our histories by use of the Internet, personal computers, and scanners, so that they may be studied and shared in printed form.

I have built a virtual time machine. Step in and take leaps through the past of our town. *Syosset People and Places* begins near the Long Island Rail Road station and takes you around the station and the railroad through the middle 1800s to the middle 1900s. Then go back to 1685 and visit the home of the Schenck family, Dutch pioneers. From there, travel around town and join the people in their homes and businesses spanning 200 years. See the way they looked and dressed in times gone by. Set the controls to travel to Syosset's Gold Coast estates to observe how the wealthy lived and died and see those who worked for them, who led equally interesting lives.

War interrupted the day-to-day lives of Americans in the 20th century. Travel back to World Wars I and II and observe Syosset's men and women fighting for democracy overseas and supporting the troops on the home front. Then go back to the creation of Syosset's post office and see a history of its mail delivery. From there, return to the beginning of Syosset's volunteer fire department and follow the brave "vamps" into the latter part of the 20th century. Drive south on Syosset's main street, Jackson Avenue, and visit the recreational attractions on Jericho Turnpike in the mid-20th century.

Set the time back to 1893 and check the status of Syosset's public school. Visit the early grade schools and the children from the early 1900s to the mid-1950s and beyond with scenes from Syosset High School.

By the time you depart from my virtual time machine, you will have seen Syosset grow from a small pioneer farming community into a populous suburb. The expansion began with the coming of the Long Island Rail Road and has continued with the shining success of Syosset's school system. Syosset retains its charm while it makes necessary improvements to serve its citizens. It is a wonderful town.

Welcome home!

# PIZZA

nd other FINE ITALIAN DISHES!

TAKE—OUT ORDERS:

## WA1-9778

*Our* SAUCE TAKES 12 HOURS!

## CHRISTIANO'S ITALIAN CUISINE

19 IRA ROAD, SYOSSET  1 block so. of R. R. Sta

### ENTERTAINMENT WEEKENDS

Christianos's Italian Restaurant at 19 Ira Road, just south of the Long Island Rail Road station, was founded in 1958 and has offered fine cuisine well into the 21st century. It has been said in many circles that Billy Joel, from Hicksville, referred to Christiano's Italian Restaurant in his song "Scenes from an Italian Restaurant." Evidence points in that direction, as Rose Horton worked there for 30 years and her son Dan "Fing" Horton was the lead guitarist for the legendary band the Reasons Why, contemporary in 1967 with Joel's group, the Hassles, which included Syosset personnel. (Author's collection.)

# One

# DOWN BY THE STATION AND THE RAILROAD

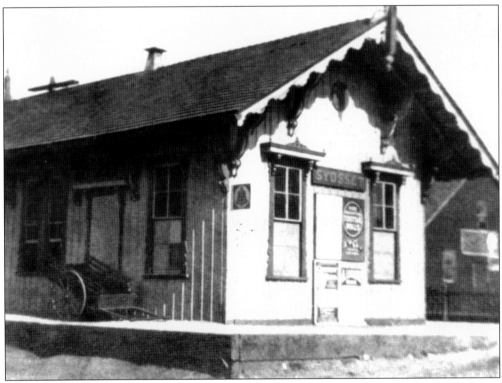

In the late 1840s, people in the sparsely populated farming community of Eastwoods began to call their community Syosset. The Long Island Rail Road (LIRR) arrived in July 1854 and officially designated the new station Syosset. The station house, pictured around 1913, was brought to Syosset from a closed station in Far Rockaway in 1877. The presence of the LIRR in Syosset led to rapid growth and development. (Courtesy of Tom Montalbano.)

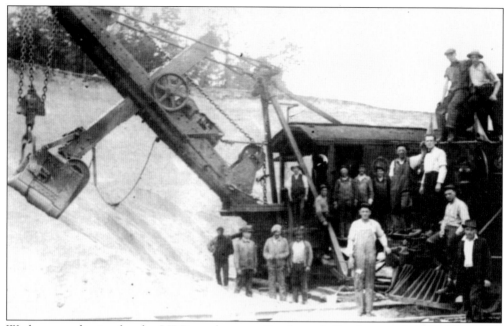

Workers are digging by the LIRR tracks, near Southwoods Road, around 1910. The earth excavated here was used to elevate the Jamaica LIRR station. The workers also replaced a street-level crossing with a bridge over the tracks. A deep channel was left that went under Southwoods Road. Without meaning to, the designers and workers on this project created the Swamp. (Courtesy of the State University of New York at Stony Brook Special Collections Library, Robert Emery Collection.)

Syosset High School was built adjacent to the Swamp. Generations of students have been drawn to it both to explore it as a challenge and to use it to escape from academic pursuits. The starkly beautiful and timeless swamp is pictured above in the winter of 2003, as the author revisited it after an absence of over 50 years. (Author's collection.)

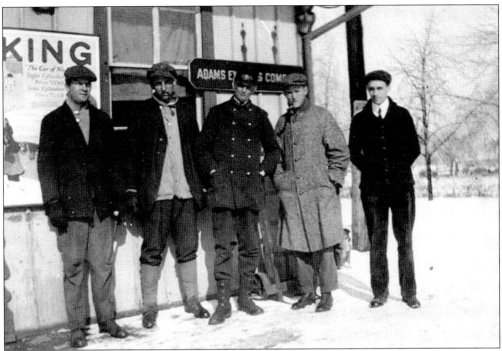

A group gathers at the LIRR station in 1916. Pictured are, from left to right, William Knettel, Eugene S. Smith, George Carnes (ticket agent), unidentified, and Lonny Brower. The poster advertises "King the Car of No Regrets." The 1916 eight-cylinder model was priced at $1,350. Smith enlisted in World War I. He perished in a German POW hospital in October 1918. American Legion Post No. 175, on Berry Hill Road, was named for him. (Courtesy of Diane Oley.)

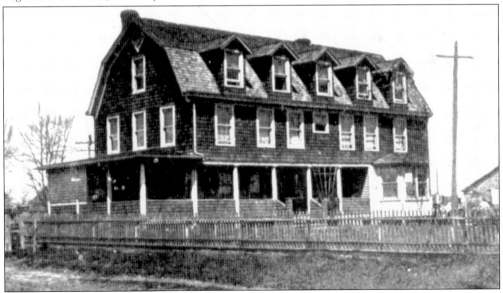

Alonzo (Lonny) Brower, who later became a railroad ticket agent, and his sister Lulu were the children of John and Mary Brower. The Brower Boardinghouse beside the LIRR station (near what later became Ira Road) accommodated many Burden estate workers in 1916. It remained standing into the early 1960s. (Courtesy of Tom Montalbano.)

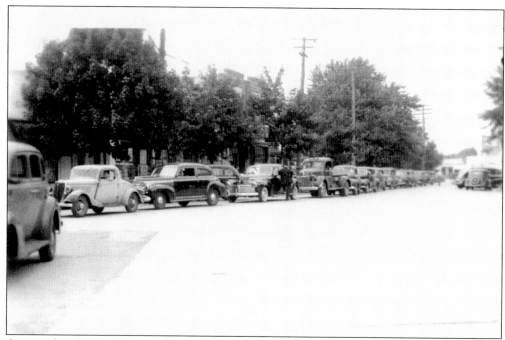

Cars are lined up as far as the eye can see on the west side of Jackson Avenue heading south to the train tracks. This 1940 photograph represents a typical scene as the trains arrived and departed as the watchman operated the manual gates. The gates were automated in 1951, but traffic jams have always been the rule at train times. (Author's collection.)

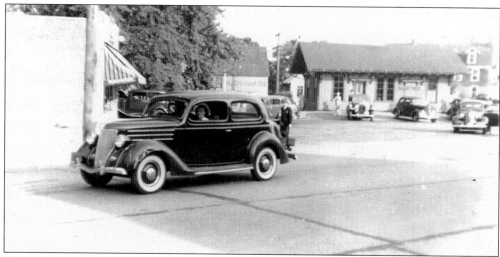

This view by the LIRR station shows a less crowded Jackson Avenue in 1937. The 1936 Ford Touring Sedan in the foreground is passing Abe Weinstock's variety store, which was right there to meet commuters' needs. The building to the left of the station, across the tracks, is part of John Young's Syosset Coal and Supply Company. The Brower Boardinghouse is to the right. (Author's collection.)

Abe Weinstock, who also had a store in Hicksville, provided such a variety of products that children called Weinstock's the "Everything Store." It even had a circulating library. Manny and Gert Weintraub had recently bought Weinstock's store, and on Washington's Birthday in 1953, a fire started in the basement and destroyed most of the inventory. It temporarily relocated to Boslet's Restaurant, selling newspapers, stationery, tobacco, and candy. (Author's collection.)

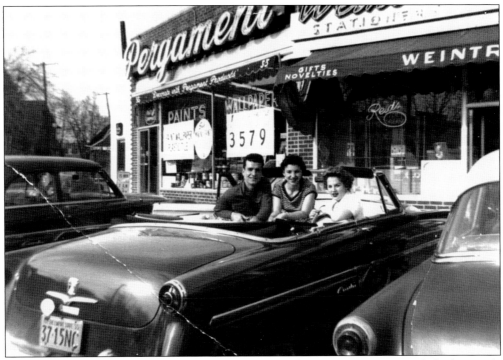

Manny and Gert soon reopened Weintraub's. It offered even more variety, and the long soda fountain featured egg creams, sandwiches, and hamburgers. Genial Jack Frankel, Gert's brother, greeted everyone at the main counter. Carl Zeoli, his niece Madeleine Zeoli, who became the owners' daughter-in-law, and Joan Konowski, who worked in the store, are pictured in 1955. Pergament replaced Franklin's Restaurant next door and was a presence in Syosset before it became a large franchise. (Courtesy of Madeleine Weintraub.)

13

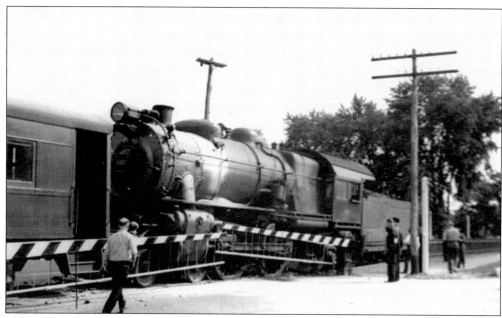

While the presence of the Jackson Avenue train crossing had its obvious benefits, there have always been some unfortunate side effects. There were accidents at the crossing with no gates and with manual gates, and the advent of the automated gates did not prevent the occasional fatality when someone tried to beat the train to the station. There were also some derailments as pictured above at the Jackson Avenue crossing in 1937. (Author's collection.)

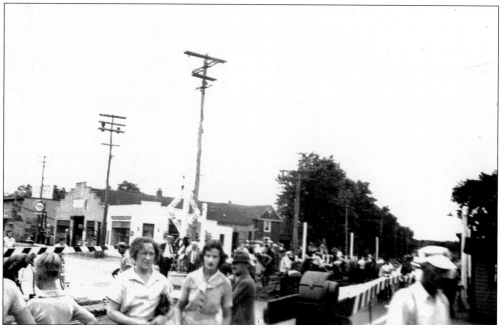

It was a big event for commuters and curious townspeople who came to see the derailed train. Looking south to Jackson Avenue, the watchman is looking north, a large crowd is on the tracks, and the Esso gas station and other stores near the corner of Railroad Avenue are probably empty. (Author's collection.)

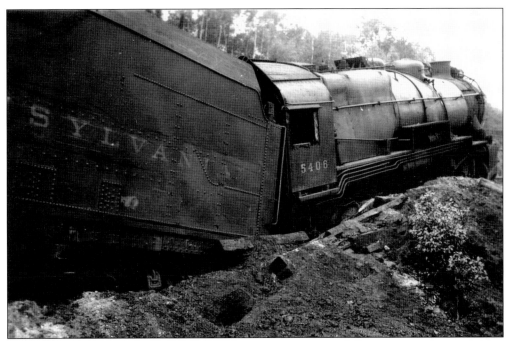

LIRR engine 5406 was pulling a commuter train west toward Syosset just after a soaking rainstorm on September 14, 1944, a result of the great Atlantic hurricane. The tracks under the Southwoods Road Bridge were undermined; the engine hit the washout and derailed into a sandpit, breaking its keystone. (Author's collection.)

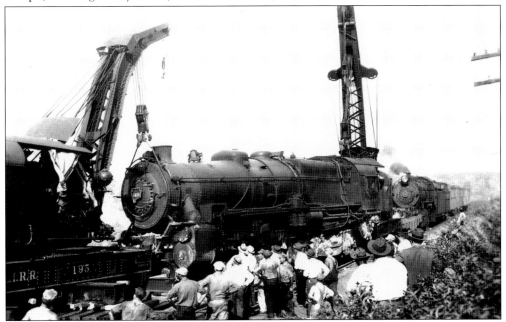

The next day, as many residents watched, Donald Boslet took these award-winning photographs of the derailed train and the ensuing cleanup. Harry A. Glueck, an LIRR executive, supervised the cleanup crew and the return of the engine to the Pennsylvania Railroad, where it was rebuilt and its keystone restored. It returned to active duty. (Author's collection.)

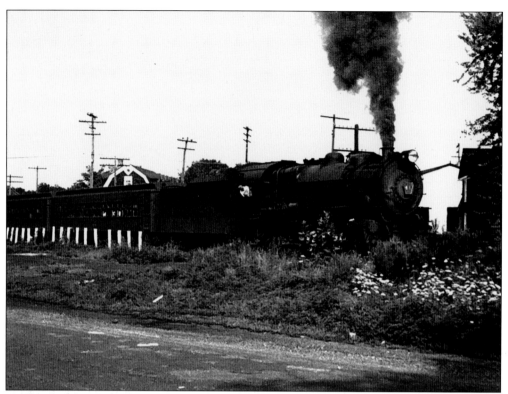

A coal-powered steam engine chugs through the town on September 15, 1944, the day the great Atlantic hurricane landed on Long Island. Steam locomotives were a common sight until the 1950s, when seeing one was a rare treat for young and old. Finally all the few remaining LIRR steam locomotives were retired in October 1955. (Author's collection.)

Craig's Taxi was a fixture in Syosset for many years. The stand was on Jackson Avenue right at the station, convenient for commuters, shoppers, and those who did not want to risk driving after too much celebration in the local bars. Craig's Taxi advertised in the official LIRR timetable for Syosset and Cold Spring Harbor; this advertisement is from the schedule effective December 15, 1962. (Author's collection.)

# Two

# Around Town

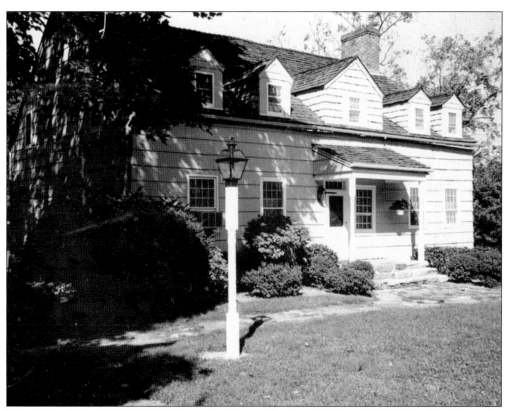

The Schenck family built their home in Eastwoods about 1685 to 1710. It faced south to the trail that became Jericho Turnpike. By 1900, the home and surrounding farmland belonged to George Mann. The house was purchased around 1945 by Raymond Burckley and restored. It was added to the Department of the Interior's National Register of Historic Places in 2005. This 1993 photograph shows a rare front view of the house. (Courtesy of Ronald Burckley.)

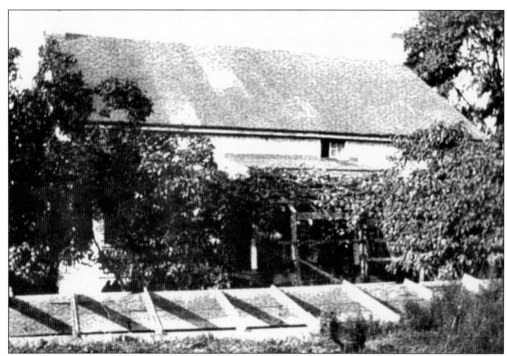

The front of the Schenck-Mann house is pictured on July 28, 1943. It has a summer kitchen attached on the west side. A door leads to the regular kitchen. A large, sectioned wooden planter is in the front yard. The foliage is overgrown and there is an arbor directly in front of the house's main entrance. Raymond Burckley had his work cut out for him. (Courtesy of Ronald Burckley.)

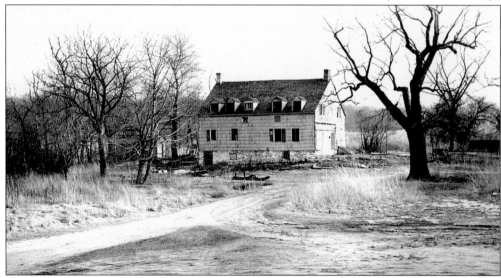

The house was in disrepair, snow was coming in, and the quaint summer kitchen was unsalvageable. While clearing the overgrown vegetation, he discovered the venerable and beautiful pond. This 1947 view of the house from Convent Road shows the Schenck-Mann-Burckley house under repair and restoration with dormers under construction. Note the 600-year-old Black Walnut tree to the right of the driveway. The trunk is seven feet in diameter, and the tree has survived with new growth into the 21st century. (Courtesy of Ronald Burckley.)

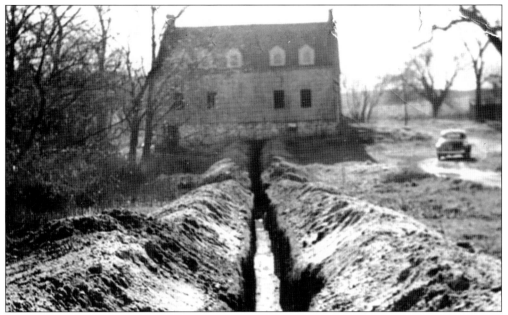

The house had no heat, nor did it have indoor plumbing. Before he could move in with his wife, Jean, and their three sons, John, Ronald, and Steven, he had to supply the house with water piped in by the Jericho Water District. He dug this trench from Convent Road by hand. It was 300 feet long, 4 feet wide, and 12 feet deep. (Courtesy of Ronald Burckley.)

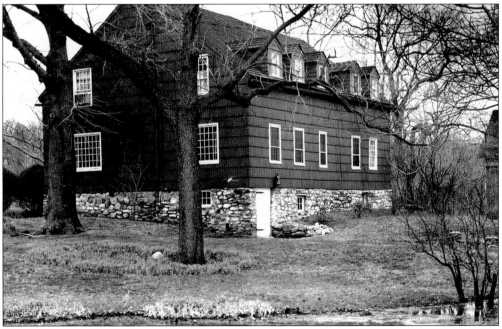

This is an east side and rear view of the fully restored Schenck-Mann-Burckley home. The original 17th-century stone foundation is displayed with the door leading to the basement. The south bank of the pond is visible. The pond was a favorite spot for skating and ice hockey for many years. After the Burckleys sold the house and land, the pond became part of the new owner's private nature preserve. (Courtesy of Ronald Burckley.)

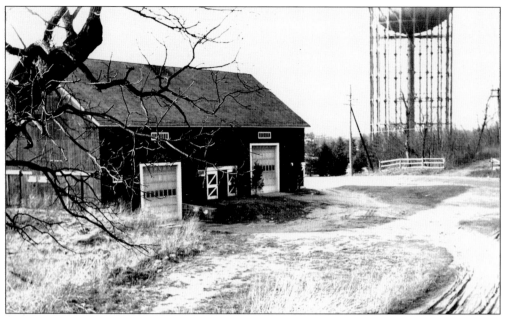

A few years after the Burckley family moved into their home, Raymond purchased more land to the west from the Van Sise family. His new property included two barns. This barn, photographed on March 23, 1947, was the closest to Convent Road. It was destroyed by fire in the mid-1950s. At various times, Convent Road had been known as Schenck's Lane, Nostrand Avenue, Academy Road, and Mann's Road, among others. (Courtesy of Ronald Burckley.)

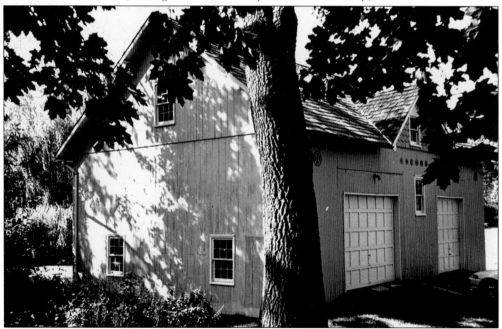

The second barn, located further back from Convent Road, is shown in 1993. It was constructed about 1901. In recent years, the owner moved it closer to the west bank of the pond. This picturesque structure, known as the Schenck-Mann Barn, received town landmark status from the Oyster Bay Town Board. (Courtesy of Ronald Burckley.)

Ronald Burckley, standing, and Jon Michael "Mike" Hofgren of Pine Road are ready to sled down Hofgren's Hill (formerly Mann's Hill) in January 1957. The hill was behind the Village School. The school was constructed in 1954 on what once had been part of the George Mann farm. Before the Manns, the land was owned by Stefan Schenck. (Courtesy of Priscilla King.)

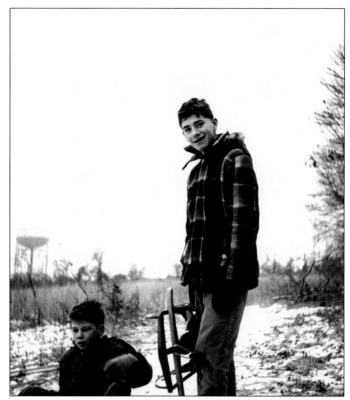

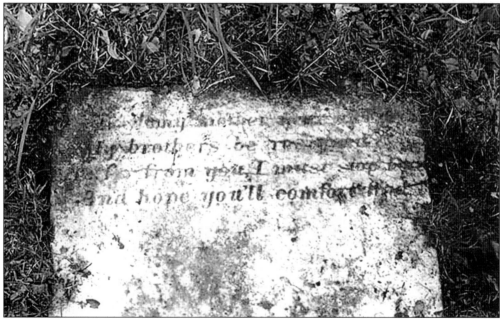

The Schenck cemetery is on Convent Road to the west of St. Mary of the Angels Home. A partial rendering of this stone reads, "And hope you'll comfort him." There were 44 burials spanning most of the 19th century, including members of the Schenck, Baldwin, Ellison, Lewis, Marshall, McElvey, Van Sise, and Wanser families. (Courtesy of Tom Montalbano.)

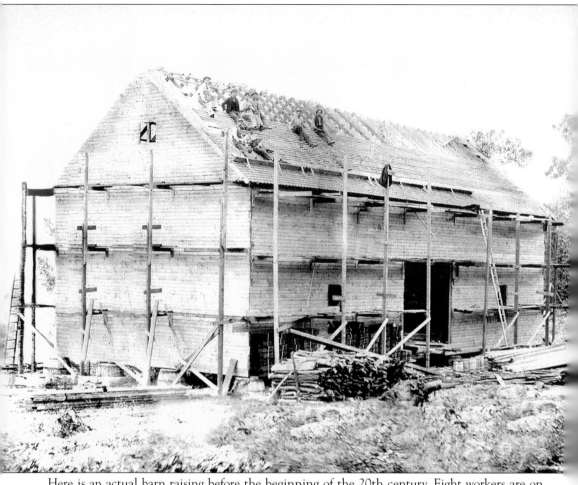

Here is an actual barn raising before the beginning of the 20th century. Eight workers are on the roof, some wearing jackets, vests, and neckties. The site is on the Sisters of Mercy property across from their newly built St. Mary of the Angels Home. The home was still using the barn for storage into the 21st century. (Courtesy of Ronald Burckley.)

The Community Church at 36 Church Street, shown in the 19th century, was established in 1860 as the Free Church. It stood on a one-acre lot donated by the merchant Samuel W. Cheshire. Five residents directed the construction, which cost approximately $1,300. It was welcome to all denominations. (Author's collection.)

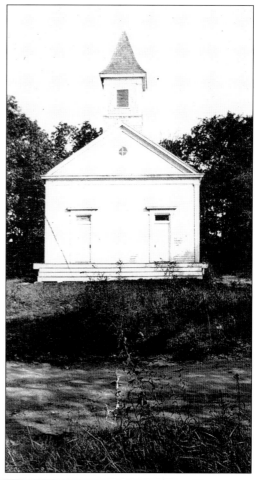

## Nassau County.—Oyster Bay.

| Name of School, Denominational or Union and its Location. | Name of Superintendent. | Name of Secretary. | Name of Pastor. | Teachers and Officers. | Scholars. | Home Dept. | TOTAL. | Conversions or Confirmations. | Monies contributed during the year for all purposes. |
|---|---|---|---|---|---|---|---|---|---|
| Oyster Bay, Pres | Alex. G. Russell | Harry Coombs | Rev. A. G. Russell | 20 | 121 | | 141 | | $130 00 |
| " M E | Theo. Velsor | Herbert F. Phillips | Rev. W. I. Bowman | 20 | 115 | 40 | 175 | | 140 00 |
| " Bapt | Chas. S. Wightman | | Rev. Chas. S. Wightman | 8 | 50 | 20 | 78 | | 88 28 |
| Glen Cove, Pres | Dr. J. S. Cooley | John C. Small | Rev. J. A. Norris | 13 | 134 | | 147 | | 173 60 |
| " M. E. | John C. F. Davis | G. E. Raynor | Rev. J. W. Eggleston | 15 | 92 | | 107 | | 62 25 |
| " Epis | Victor Lecoy | Joseph Duffee | Rev. J. D. Gammach | 9 | 76 | | 85 | | 150 00 |
| " A. M. E. | Rev. Wm. H. Lacey | Miss Estelle Parker | Rev. Wm. H. Lacey | 5 | 20 | | 25 | | 6 00 |
| Glenwood, Pres | Jesse V. Golden | R. Latourette | Rev. Jas. N. Grace | 9 | 61 | | 70 | | 7 17 |
| Sea Cliff, M. E. | Egbert Rinehart | S. C. Ransom | Rev. George N. Carter | 40 | 189 | | 229 | | 371 50 |
| " Ger.M.E. | John C. Kenneth | Geo. Anerheim | Rev. George H. Mayer | 10 | 42 | | 52 | 4 | 215 00 |
| " P.E. | G. G. Chapham | | Rev. N. D. Morgan | 16 | 86 | | 102 | | 100 00 |
| Hicksville, Ger. Luth | Wm. Jaegle | H. Matschat | Rev. P. Matschat | 26 | 140 | | 166 | 15 | 190 00 |
| " Ref | C. A. Wetterman | Wm. Christ | Rev. P G. L. Matschat | 27 | 160 | | 187 | | 280 00 |
| Lattingtown, Union | J. R. Clarke | H. Ingrabam | Rev. Charles N. Flint | 7 | 34 | | 41 | | 40 00 |
| East Norwich, M. E | W. F. Johnson | Alice Warthing | Rev. Benj. C. Miller | 8 | 86 | 30 | 124 | | 184 00 |
| Farmingdale, M. E. | F. M. Denton | F. H. Brown | Rev. S. A. Sands | 23 | 124 | | 147 | | 34 00 |
| Brookville, Ref | J. F. Wright | Chas. Titus | Rev. W. D. Ward | 13 | 87 | | 100 | 4 | |
| Woodbury, M.E. | D. S. Whitney | Samuel Cheshire | Rev. B. C. Pilsbury | 8 | 65 | | 73 | | 40 00 |
| Locust Valley, Dutch Ref | E. Van Wagner | Miss Mae E. Thomas | Rev. H. H. Shook | 6 | 31 | | 37 | 3 | 1 00 |
| Syosset, Union | Mrs. A. B. Cagwin | Austin C. Cheshire | Rev. A. Russell | 9 | 61 | | 70 | | 15 00 |
| Bayville, M. E. | S. D. Perry | M. Perry | Rev. C. N. Flint | 9 | 90 | | 99 | | 26 45 |
| Massapequa, P. E | Rev. Wm. Wiley | Miss L. E. Wiley | Rev. Wm. Wiley | 7 | 64 | | 71 | 6 | |
| TOTALS | | | | 308 | 1928 | 90 | 2324 | 32 | $2254 25 |

By 1905, the church was named the Union Church. The Annual Statistical Report of the Sunday Schools in Nassau and Queens County shows the Syosset church with 9 teachers and 61 students with $15 contributed for the year. The pastor, superintendent, and secretary were Rev. A. Russell, Mrs. Allison (Evelin) Cagwin, and Austin C. Cheshire, respectively. (Author's collection.)

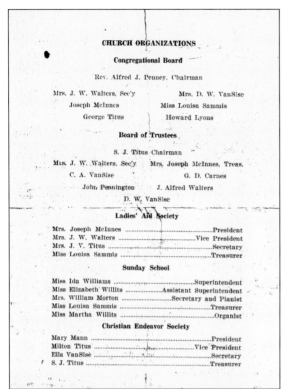

**CHURCH ORGANIZATIONS**

**Congregational Board**

Rev. Alfred J. Penney, Chairman

Mrs. J. W. Walters, Sec'y      Mrs. D. W. VanSise
Joseph McInnes      Miss Louisa Sammis
George Titus      Howard Lyons

**Board of Trustees**

S. J. Titus Chairman

Mrs. J. W. Walters, Sec'y    Mrs. Joseph McInnes, Treas.
C. A. VanSise      G. D. Carnes
John Pennington      J. Alfred Walters
D. W. VanSise

**Ladies' Aid Society**

Mrs. Joseph McInnes .........................President
Mrs. J. W. Walters .........................Vice President
Mrs. J. V. Titus .........................Secretary
Miss Louisa Sammis .........................Treasurer

**Sunday School**

Miss Ida Williams .........................Superintendent
Miss Elizabeth Willits .........................Assistant Superintendent
Mrs. William Morton .........................Secretary and Pianist
Miss Louisa Sammis .........................Treasurer
Miss Martha Willits .........................Organist

**Christian Endeavor Society**

Mary Mann .........................President
Milton Titus .........................Vice President
Ella VanSise .........................Secretary
S. J. Titus .........................Treasurer

By 1931, the church had become the Community Church. This rare document outlines the church organization at that time with many prominent Syosset families represented; among them are Carnes, Sammis, Titus, Walters, Willits, and Van Sise. The pastor was Alfred J. Penney, and the organist was Susan Carnes. (Author's collection.)

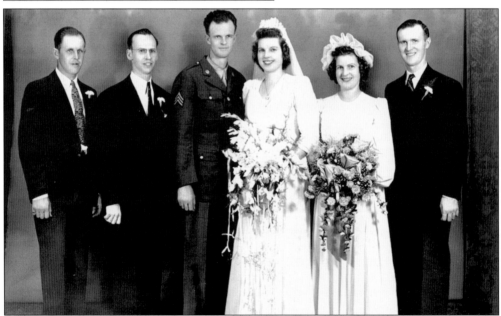

Mildred Knettel and Sgt. Forrest Vanstane were married in the Community Church August 5, 1944. Pictured are, from left to right, Jerome Suydam (usher), Glenn Cook (best man), Forrest, Mildred, Mrs. Thomas Taylor (matron of honor, formerly Leone Knettel), and Robert Boslet (usher). Cook had varied careers in Syosset. He worked in the post office and later became a funeral director and owner of the Glen Pharmacy. (Author's collection.)

The Community Church in 1953 served a growing postwar congregation after being remodeled and enlarged in 1950. The exterior was restored to its original white color, a lamppost and the church sign were added, and the entrance was moved to the new rear wing with a walkway leading to it. (Courtesy of Diane Oley.)

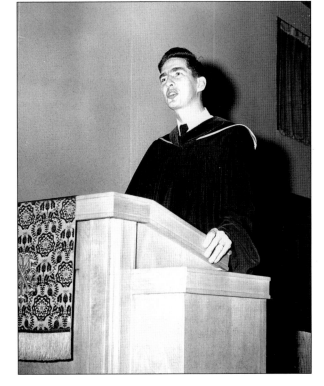

Rev. William A. Irish, shown preaching at the pulpit in the mid-1950s, served the parishioners from August 1955 to August 1965. His youth, charisma, and knowledge were well matched to the growing congregation. He gave invocations and benedictions at many school graduations, serving the community at large as well. (Courtesy of Christine Irish Morisco.)

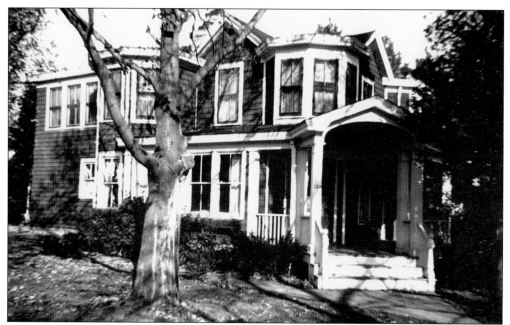

During their stay in Syosset, the Irish family lived at 149 Berry Hill Road, the church parsonage. This charming Victorian house had once been the Bermingham homestead. Henry J. Bermingham had developed the property on the east side of Jackson Avenue, erecting the stores that have been patronized under many owners for generations, persisting into the 21st century. (Courtesy of Christine Irish Morisco.)

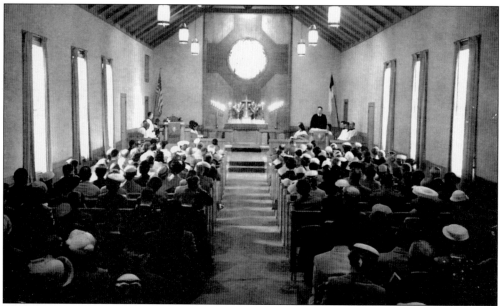

Above is a typical Sunday service in the 1950s showing Rev. William Irish giving a sermon to his flock. All the pews are filled. A new Christian education building was added along with a 70-space parking lot in 1958. The church staff was expanded to include the first full-time Christian education director, Susanna Menah, and a full-time associate minister, Rev. John Paul Peck. (Courtesy of Christine Irish Morisco.)

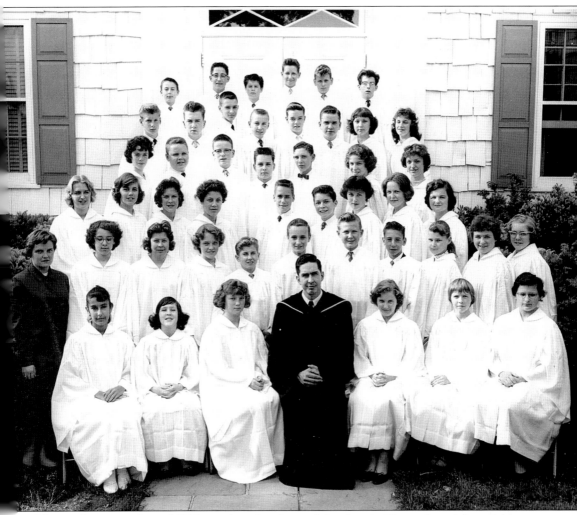

The confirmation class of 1960 is gathered in front of the church. Shown from left to right are (first row) Ann Mezey, Mary Ludlam, Judy Armstrong, Reverend Irish, Lynn Kachner, Christine Irish, and Barbara Billings; (second row) Jessie McGovran, Mary Ann McClintock, Lynn Holthausen, Susan Christiansen, Frank Stark, Lloyd Keigwin, Karl Rohr, Peter Sailon, Beverly Raine, Linda Gillet, and Constance Morrison; (third row) Carol Williams, Cheryl Boyle, Dale Lumme, Carol Piana, Henry Smith, Christopher Thralls, Marion Barry, Judy Palamar, and Linda Howlett; (fourth row) Jill Niemond, Ronald Reilly, Kenneth Meyer, James Kapey, Michael Claypoole, Nancy Herrmann, and Tiffany Grundy; (fifth row) John Hilz, Bruce Morrison, Raoul Bataller, William Chabina, John Haass, John Morrison, Diane Dickey, and Pamela Kunze; (sixth row) Peter Jones, Richard Williams, Bruce MacGregor, Richard Kantro, Raymond Kahler, and Richard Hulley. In 1962, The Syosset Community Church joined the United Church of Christ and became a part of that denomination. (Courtesy of Christine Irish Morisco.)

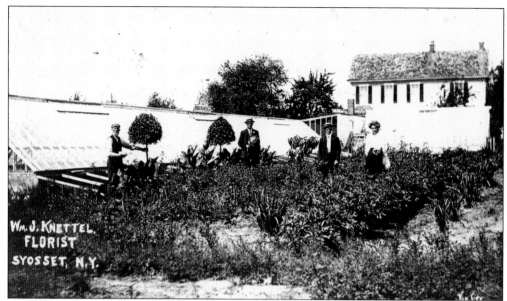

William J. Knettel's "Morning Glory Florist: Bulbs, Plants and Cut Flowers," around 1899, was on Dora Weber's property at 1 School House Lane. The Dutch-constructed house dates from 1728. German-speaking society people came every weekend from New York City and held parties. Knettel is on the left with his son William L., who is holding a bouquet. (Courtesy of Diane Oley.)

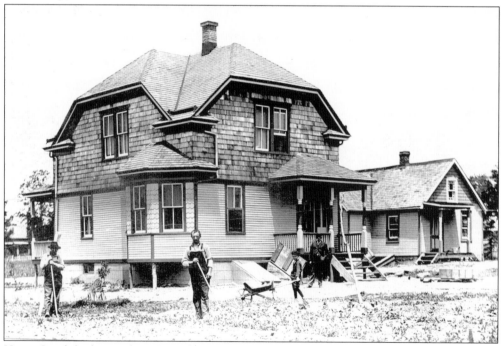

Henry Smith had come from Greenlawn with his wife, Carrie, and their 10 children to manage the McGuire Pickle Works. This large house on High Street, off what became Cold Spring Road, was built especially for his family, shown above in 1916. By 1910, Henry had died, and his son Henry Jr. was the superintendent of the factory. (Courtesy of Diane Oley.)

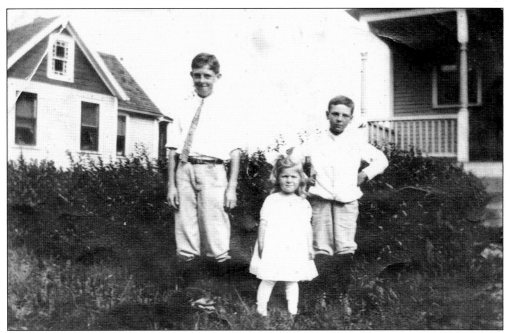

Laura Smith had lived in the big house with her parents. She married William L. Knettel; their children, Leone and Mildred, were born in the house next door. Above is Leone Knettel with uncles Clarence "Dunk" (left) and Raymond "Birch" Smith, around 1913. The Lawrence Zabel family later lived in the big house until 1960. After they moved, both houses were torn down to make more room for the LIRR parking lot. (Courtesy of Diane Oley.)

Ice skaters from all over the town gathered at the pond at Syosset-Woodbury and Cold Spring Roads, shown above in the 1920s. It had once been Cheshire's Pond, when Albert Cheshire owned it and the land around it. Sometime in the 20th century, it was dubbed Pelican Pond, and that name persisted. (Author's collection.)

Mary Wencko was one of the Bank of Syosset's first depositors in 1928. The bank had been founded in 1927 by Albert M. Bayles and Thomas Ryan; one of its first directors was Howard Kreutzer. It was housed at 29 Jackson Avenue and Syosset's first police booth was installed across the street. (Courtesy of Mary Wencko Gaida.)

No. 380

# BANK OF SYOSSET

## SYOSSET, N. Y.

(Mrs.) IN ACCOUNT WITH

*Mary Wencko*

*Syosset, N.Y.*

## Interest Department

Open on Saturday from 8.30 A. M. to 12 M.
Other days from 8.30 A. M. to 3 P. M.
Open Monday Evenings 6:30 to 8:30
CLOSED ALL HOLIDAYS

Read the Rules in this Book carefully. If you lose
or mislay it give immediate notice to the Bank.

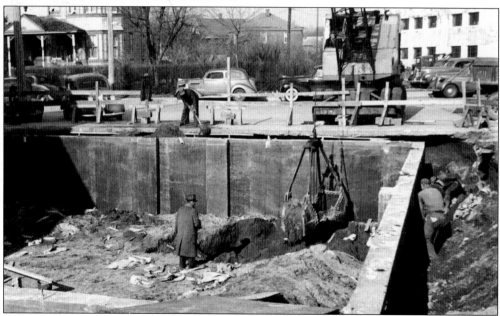

In 1942, Crouchley General Contracting of Westbury was hired to construct a much larger building to accommodate the growing bank. In the scene above, the foundation is visible, and a supervisor is overseeing the digging of the basement. Looking across the street, the Catherine Taylor Employment Agency is on the left, then houses on Whitney Avenue and 18 Jackson Avenue, at that time Republic Aviation, is on the extreme right. (Author's collection.)

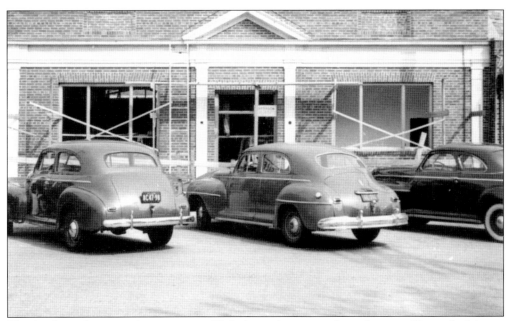

The bank is almost ready to open at 33 Jackson Avenue and employees will not find it too difficult to move people, records, and money from the building next door. On December 1, 1953, the Hempstead Bank, established in 1887, accomplished its first merger by acquiring the successful Bank of Syosset. (Author's collection.)

This is a scanned image of an actual Bank of Syosset moneybag, around the 1940s. The Syosset branch of the Hempstead Bank moved across the street to 18 Jackson Avenue in December 1963. The bank later became Norstar, then Fleet, and merged with the Bank of America in the early 21st century. (Author's collection.)

Bernard Poole (a chauffeur visiting from Maine and the brother-in-law of Clarence "Dunk" Smith, back left), Charles DeMilt (front left), and Henry (back right) and Frank Smith (brothers of Laura Smith Knettel) pose in a convertible of the period, about the 1920s. DeMilt, nicknamed "Dusty," at that time operated the DeMilt Sweet Shop and Candy Store in the front room of the old Spreer's Hotel. (Courtesy of Diane Oley.)

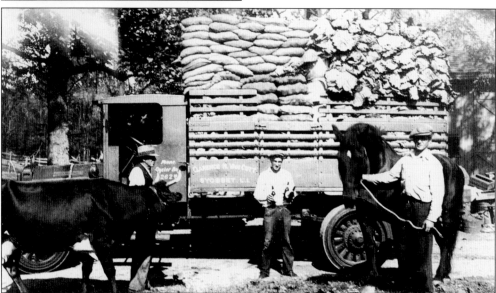

The Clarence Van Cott truck farm was located at the sharp S curve on Split Rock Road, east side, before Route 25A. Seen here in 1930, loaded for market with potatoes and cabbage, the truck has solid rubber tires and no doors. Clarence Van Cott is 28 years old and holding three bottles of beer to share with his buddies who are minding the horse and cow. (Courtesy of Mary Wencko Gaida.)

Mildred Knettel and Dot Van Sise pose near Convent Road on February 7, 1932, after purchasing their new coats in New York City. There was no place to obtain store-bought clothing in Syosset until the late 1930s. One had to travel to bigger towns such as Huntington or even travel into the "City," usually by train. The water tower, seen in the background, is already a presence. (Courtesy of Diane Oley.)

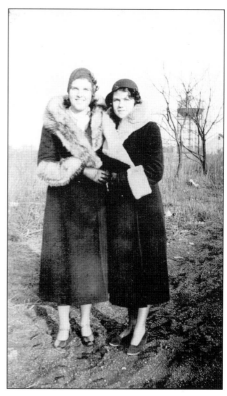

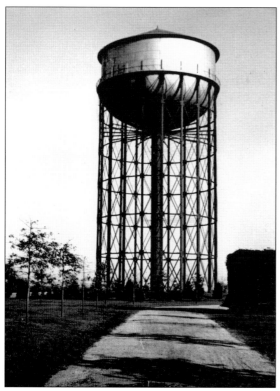

Here is a closer look at the Syosset water tower on Convent Road, shown in the late 1930s. After it was constructed, beginning in 1930 and finished by 1932, it became the world's second-largest water tower, at 1,500,000-gallon capacity, supported by 20 columns, 78 feet in diameter, and approximately 175 feet high. If one gets lost, just look for this landmark. (Author's collection.)

The old Spreer's hotel, on Jackson Avenue just south of Whitney Avenue, had other proprietors after Mortiz "Yanke" Spreer retired. By 1930, George Hillsdon, who had emigrated from England, ran it, and shortly after, Edward Reinhardt ran it. Joseph Boslet Sr., Reinhardt's brother-in-law, had been a seafood merchant. He took over in 1934, and after his death in 1945, his sons took over. Boslet's Restaurant is shown above, with its well-kept hedge, in the mid-1940s. (Author's collection.)

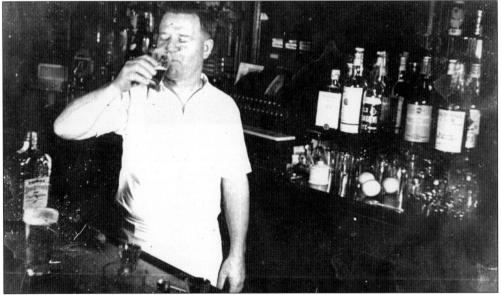

Boslet is taking a break behind the bar in 1937. Reinhardt had managed a quiet speakeasy in the establishment, but Prohibition ended in 1933. Boslet began his tenure by obtaining Nassau County's first beer, wine, and liquor license. He continued, as did his predecessor, to operate his business solely as a restaurant. However Boslet's Photo Service was incorporated into the building and for years developed most of the townspeople's photographs. (Author's collection.)

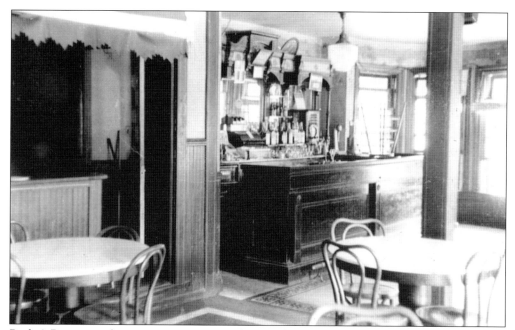

Boslet's Restaurant became a major town-gathering place and meeting hall. Joseph Boslet joined the crowds at the 1939–1940 New York World's Fair and, as countless others, saw television for the first time. Boslet and his wife, the former Winifred Youngman, had foresight and good business sense. In 1941, they invested in a nine-and-a-half-inch television and placed it in the restaurant. It was a sensation. People would watch anything that came on, both sports and the mundane. It was the only television in town. (Author's collection.)

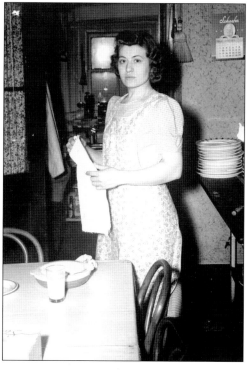

Boslet's Restaurant was a busy place in the 1940s. Estate and defense plant workers kept the staff moving to serve drinks and meals. The menu might have included, hot roast beef, ham, or turkey dinner, with potatoes, three slices of bread, and two vegetables for 40¢ and a 14-ounce glass of beer for 10¢. Nell Nowak married Joseph Boslet's son Robert in 1939, and she does not look too happy in this image, after being recruited for kitchen work. (Author's collection.)

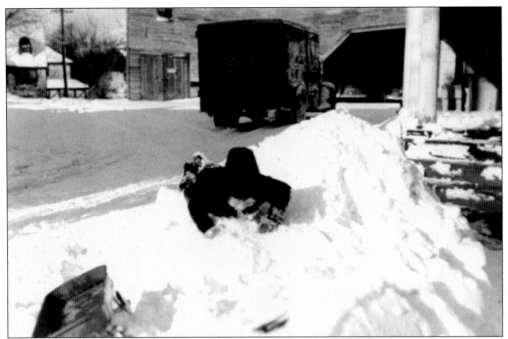

Robin Boslet, Nell and Robert Boslet's son, is playing after one of the major Syosset snowfalls as a Ballantine beer truck arrives for a delivery on February 9, 1945. It is heading for a parking garage that once housed the hotel patrons' horses, carriages, and grooms. In back of Boslet's Restaurant were two other old structures: an icehouse and a pump house with a very deep well. (Author's collection.)

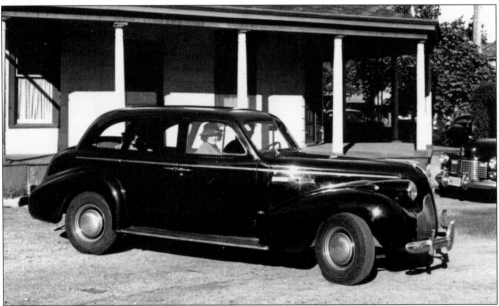

Winifred Boslet is a passenger in her son Robert's car, on the south side of the restaurant, around 1950. This 1940 Cadillac with a roll-up window between the front and back seats (controlled from the back seat only, a wonderful device for the children to shut out their parents) was bought by Robert from one of the local estates. (Author's collection.)

After a dispute with the property owner Rudy Janke, the Boslet sons closed the restaurant in 1952. Janke demolished it about 1955, and by the late 20th century, the site of the beloved old hotel was a bank parking lot. This was the building next to Boslet's Restaurant toward the north, Catherine Taylor's employment agency and her home. It was torn down at the same time, and the site became part of the same parking lot. (Author's collection.)

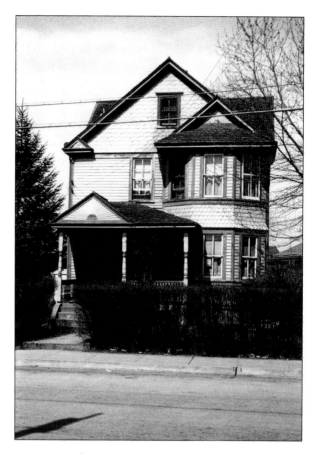

No car tracks are visible in this scene at the fork of Split Rock and Berry Hill Roads in the winter of 1934–1935. The old cannon at the World War I memorial is protected by a metal shield. The fork in the 1950s became the site of a police booth that had once been the watchman's shack at the Jackson Avenue train crossing. One or two policemen manned the booth in peaceful mid-century Syosset. (Author's collection.)

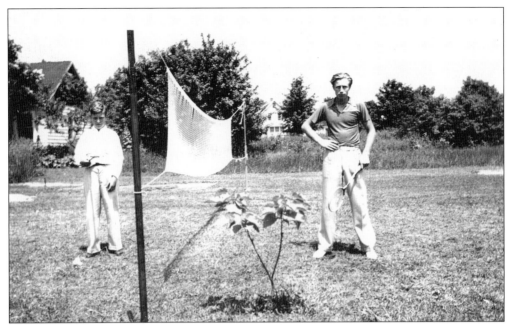

Harold and Fredrick, the sons of Harry and Edith Appleton of Meadowbrook Road, pause to pose during a game of badminton, around 1935. From about 1930, Harry had provided a riding academy at his Appleton Stables on Cold Spring Road, across from where the second Syosset Fire House was established in the 1950s. (Courtesy of Diane Oley.)

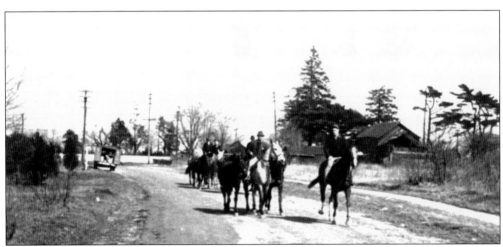

Horseback riding was not confined to special trails or riding academy circles. Equestrians freely navigated the streets such as in this scene on Meadowbrook Road in 1941 as horsemen ride from Berry Hill Road. Sir Ashley Sparks's woods are in the background. Meadowbrook Road is paved, and note that there is a sidewalk on the south side. (Author's collection.)

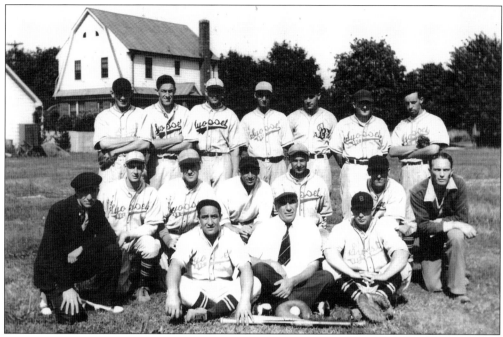

The Syosset Ball Club, 1936 Long Island champions, had its home games at Summers' Field, which was bordered by Berry Hill Road, East Street, and North Street. Dan Lynch, manager, is in the front row center wearing a tie; Frank Manarel, considered to be Syosset's most influential educator for over 30 years, is in the back row, third from right. (Courtesy of Sally Anne Lynch.)

In 1926, 24-year-old John Schulz left Germany, and by 1930, he was a machinist living on Split Rock Road with his wife, Hanni. Charles Krebs, 12 years his senior, was a boarder in the household. In two short years, they had begun a partnership that would span much of the century. Pictured above is the original Krebs and Schulz full service garage in the triangle between Jackson Avenue and Cold Spring Road. (Author's collection.)

In 1937, Leone Knettel and Evelyn (Evvie) Diel are conversing while walking south on Jackson Avenue on the west side of the street. The friends are wearing identical dresses, like sisters often have done through the ages. Maybe it was in vogue for young women then or just a 1930s fad. (Author's collection.)

Evvie married Milton Titus. She was a daughter of Lewis and Julia Diel. She had worked as a bookkeeper in a local meat market. The Titus family was active in the Community Church. Titus was the vice president of the church's Christian Endeavor Society in the early 1930s and the son of George Titus, a builder, who lived on Berry Hill Road. (Author's collection.)

Lewis Diel in shown in his backyard, around 1937. The edifice on his left looks like an outhouse. He was an upholsterer and ran a business in his home. Moritz "Yanke" Spreer, the Diels brother-in-law, spent his last years living with them. Lewis, along with his daughter Frances's husband, Raymond "Birch" Smith, kept pet raccoons. (Author's collection.)

Lewis's son Charles poses on Jackson Avenue around 1937. Charles worked for the Boslets as a handyman and as the mail carter, carrying the mail from the train station to the post office. He was an integral part of the Syosset scene in the 1930s through the 1950s. He liked everyone, and everyone liked him. (Author's collection.)

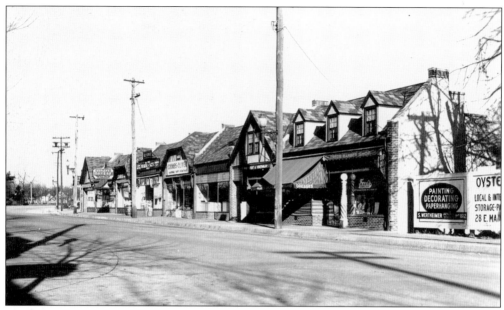

Henry J. Bermingham developed the east side of Jackson Avenue, north of Weinstocks, and these stores were some of the first, about 1939: Kohler's Bakery, the A&P Grocery, Coombs and Oliver Hardware Store (also of Bayville), the Syosset Post Office, Charlie Rella's Syosset Produce Market, Pearl Hurley's Dress Shop, and Fred's Barber Shop at No. 51. Fred Maimone had bought his business from Gaspare Puccio, who had gone on to start other enterprises. After Maimone's son Tony sold the shop in 1999, the new owners kept the name as Fred's Barber Shop. (Author's collection.)

When the 1939–1940 New York World's Fair Committee needed mature trees for its Flushing Meadows site in Queens, the Wencko family donated this tree from their backyard at 10 Jackson Avenue. It was hand dug by laborers and placed on a flatbed truck. The fire siren tower atop the firehouse on Muttontown Road is seen at top left. (Courtesy of Mary Wencko Gaida.)

Pauline Hise Galiza (1913–2006), of Dutch-English decent, came to Syosset from a farm in Medina, in Orleans County. She was a longtime Syosset elementary school teacher, equestrian, and stable owner. She married the legendary horseman Theodore (Ted) Galiza (Galitzan) in 1954 and was widowed in 1958, inheriting Galiza's Stables on Split Rock Road, just north of Muttontown Road. She is pictured at right with little Sally Anne Lynch in the late 1930s. (Courtesy of Sally Anne Lynch.)

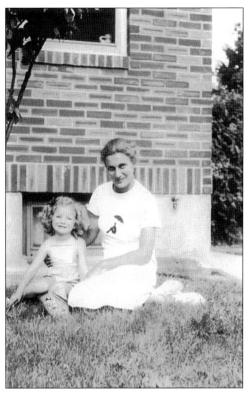

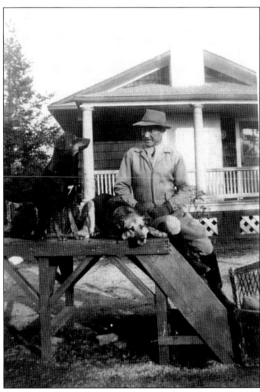

"Colonel" Theodore Galiza is outside his home with his friends Duke and Buttons in 1947. A "White Russian" fleeing communist Russia in 1923, he lived for a while in Hempstead Township and lodged with Gregory and Sonia Gagarin, descendants of a royal Russian family that had lived in exile in France. The Gagarins ran a livery stable, and Galiza, an accomplished horseman and trainer, worked there as a groom before striking out on his own. (Courtesy of Sally Anne Lynch.)

43

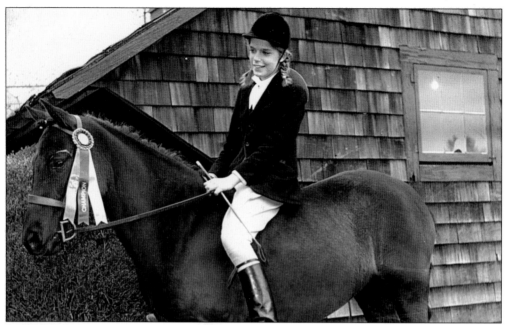

Donald and Maureen Boslet's daughter, Tricia, learned to ride a horse at age five. By age 12, she had won many prizes in the events sponsored at Galiza's Stables. This 1965 photograph shows Tricia on Baby Jane after winning the equitation division. Baby Jane's owner was Jack English (1926–1987) of Muttontown. He was a lawyer, a trusted advisor to Pres. John F. Kennedy, and a leader in the Democratic Party for many years. Another photograph below, taken in the early 1960s, shows Tricia on Joker with Mrs. Charles Earle and her young son Chucky looking on. The main ring is in the background. (Courtesy of Maureen O'Brien.)

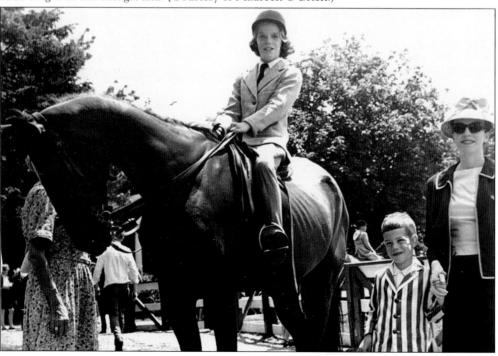

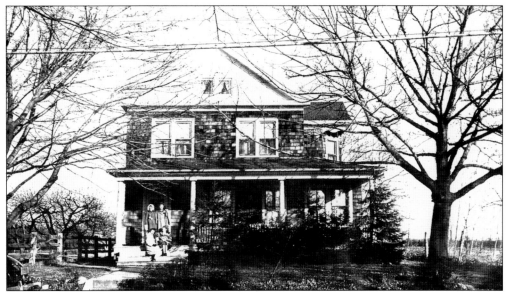

William McAuliffe and Wilhelmina Black came to America in 1911 from Ireland and Scotland, respectively, and were married in 1917. This is their home, at 196 Berry Hill Road, pictured in the early 1940s. The address became 5 Rodeo Drive by the end of the 20th century. The rear of the property abutted the Sir Ashley Sparks estate, known for its numerous apple trees. (Courtesy of Maureen McAuliffe Smith.)

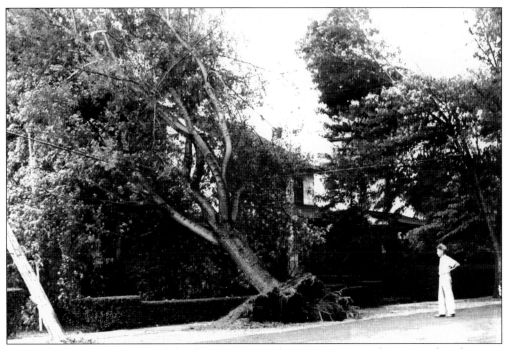

Henry Devine surveys some of the damage on North Street in September 1944 after the great Atlantic hurricane swept through Long Island. The uprooted tree fell against the telephone wires; the telephone pole was nearly toppled and the tree on the right's branches were bent. The hedge in front of the house looks untouched. (Author's collection.)

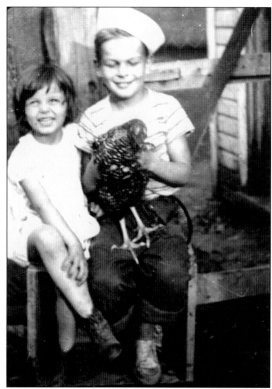

Florence and Stanley "Little Cement" Kwiatkowski, ages four and eight, pose with "the Chicken," 10 Jackson Avenue, in 1945. According to Florence, "During World War II almost every family in Syosset had chickens. Everything was rationed and chickens were a very important food source. When 'drifters' arrived in town some of your chickens would be stolen. Depending, the chickens would be sold to your neighbors or on occasion there would be a mix-up and you would buy back your own chickens. There were 'locals' that stole your chickens." (Courtesy of the Wencko and Kwiatkowski families.)

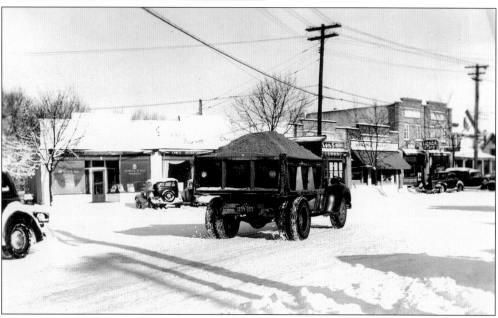

Seen here is a truck carrying salt, heading north on Jackson Avenue on February 9, 1945, after a major snowfall. The stores on the west side of the street are Charlotte M. Ryan Insurance, the Chez Rosette, Roulston's, Syosset Market, and Syosset Liquor Store. Some cars are parked vertically and others horizontally. The shops were no longer there a generation later, replaced by a bank parking lot. (Author's collection.)

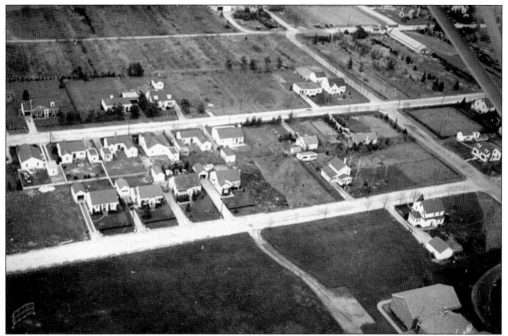

Bob Boslet captured this aerial view, around 1945, of part of Locust Grove, a subdivision of Syosset, named during the Eastwoods era. Looking northeast, Locust Grove School is in the lower right, Dawes Avenue is in the foreground, then Beatrice Avenue and Albert Avenue. (Author's collection.)

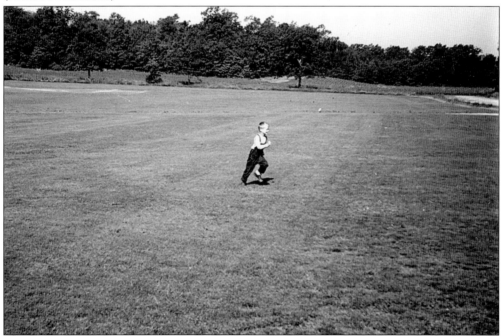

There was still plenty of room and opportunity for children to play safely in the Syosset of the postwar 1940s and 1950s. Robin Boslet is racing through the Locust Grove School field around 1945. There is not a house, car, store, or another person in sight. (Author's collection.)

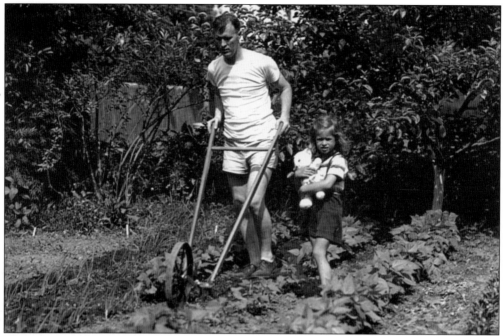

This is not a scene from "Little House on the Prairie." It is Bob Boslet and his daughter Pamela at their home on Dawes Avenue, around 1949. Victory gardens were planted all over America during World War II, both to boost the morale of civilians and to supplement the nation's food supply. Four years after the war, Bob (and Pamela) continued to maintain the garden as a hobby and for exercise. (Author's collection.)

Before the parish of St. Edward the Confessor was established in June 1952, many Syosset Catholics attended St. Dominic's Roman Catholic Church in Oyster Bay. Florence Kwiatkowski's First Holy Communion was celebrated there in 1948. She is proudly posing in the communion dress her mother made. The building behind her housed Puccio's Beauty Shop at 8 Jackson Avenue. (Courtesy of Florence Kwiatkowski Sendrowski.)

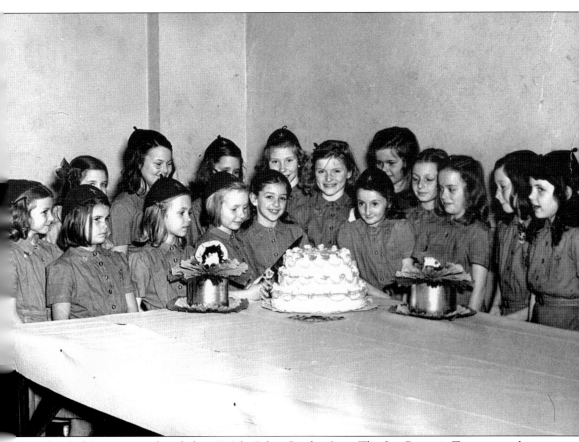

The Girl Scouts were founded in 1912 by Juliet Gordon Low. The first Brownie Troop started in Massachusetts in 1916. Nearly all Syosset girls, in grades 1 through 3, joined the Girl Scouts as Brownies. Here a troop gathers for Janet Day's birthday party in 1948. Her father, John Day, was a past president of the Syosset Public School Board of Education. From left to right are (first row) Susie Still, Elaine Hammond, Lois Ann Greenway, Janet Day (cutting the cake), Judy Manarel, Margaret White, unidentified, unidentified, and Kathleen MacNamara; (second row) Elizabeth Ann Morris, unidentified, Joan Smith, unidentified, Virginia Rieger, Brenda Van Sise, and Rose Jozwiak. The Brownie promise, from around 1954, says, "I promise to do my best to love God and my country, to help other people every day, especially those at home." (Courtesy of Lois Ann Greenway Helser.)

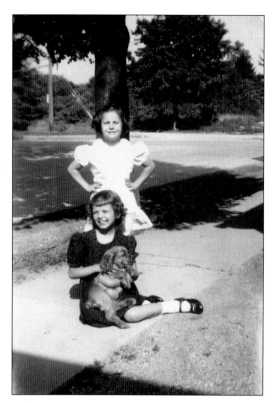

Irene Sekelsky and Florence M. Kwiatkowski are playing with Kwiatkowski's puppy around 1949, at the bottom of Muttontown Road. The junction of Split Rock and Berry Hill Roads is to their left. Around the corner is the stretch of Jackson Avenue that accommodated, at various times, the old Andrew Wencko Grocery and the barbershop, beauty salon, and tavern owned by the Puccio family. (Courtesy of the Kwiatkowski family.)

Andrew and Mary Wencko bought the house at 10 Jackson Avenue on April 2, 1925. They set up their grocery store on the ground floor. At right is a page from the account book for the Wilhelmina "Minnie" Budd family in 1932. Her late husband, Samuel Atkinson Budd (1840–1932), was a Union veteran of the Civil War. He married her, his third wife, at 78, when she was 34. These sales were made on September 2, 1932, deep in the Great Depression. A pound of coffee cost 30¢, two pounds of round steak was 59¢, and a pound of lard costs 14¢. The Andrew Wencko Grocery thrived for many years. 10 Jackson Avenue eventually became a builder's office, and the house was still used commercially into the 21st century. (Courtesy of Florence Kwiatkowski Sendrowski)

| 42 September 2 1932 | |
|---|---|
| | 4 |
| 6 bars soap | 36 |
| 1 lb. bean coffee | 30 |
| 1 bot. blue ink | 15 |
| 2 lbs. round stake | 59 |
| 2 can clover milk | 30 |
| 4 evaporated milk | 35 |
| 2 can peas | 30 |
| 1 lb. yellow cheese | 44 |
| 2 can corn | 30 |
| 1 can peaches | 25 |
| 1 box cornstarch | 10 |
| 1 lb. mix candy | 30 |
| 1 lb. mix crackers | 30 |
| 1 lb. lard | 14 |
| ½ lb. cooked ham | 24 |
| 2 lbs. large beans | 30 |
| 1 doz. oranges | 50 |
| | 542 |

Helmer J. Delin, of Bay Ridge, Brooklyn, had vacationed on Long Island with his family many times and in the late 1940s and decided to relocate. Syosset Hills was the first postwar housing development built close to downtown Syosset, consisting of identical two-bedroom ranch homes along a small stretch of Convent Road, into newly formed Greenway Drive South, Greenway Circle, and ending at Greenway Drive North. Construction was under way in 1950. (Author's collection.)

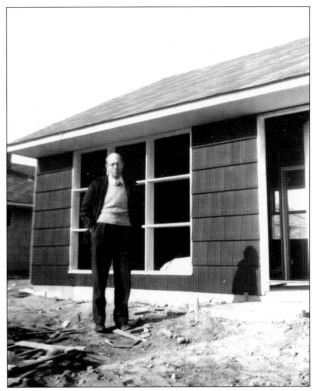

The model home, actually at 247 Jackson Avenue, became a child care center by the early 21st century. In 2007, its fair market value exceeded $800,000. Syosset Hills' homes were priced at $7,990 and ready for occupation in early 1951. Delin's home at 8 Greenway Circle came with no garage, but he added one later in 1951 for an extra $900. The property was 60 by 100 feet. (Author's collection.)

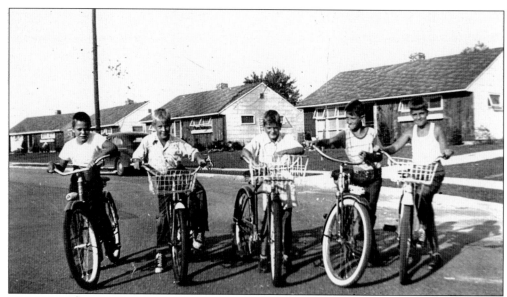

The name Syosset Hills was quickly forgotten, and the neighborhood forever became known as Greenway Circle or as residents said, the "circle." By the end of the 20th century, many of the houses had undergone extensive transformation and enlargement. Friends pose with their bikes in the summer of 1952. From left to right are Dan Lyman, Johnnie Delin, Larry Ebel, Ronald Burckley, and Steve Zajac. (Author's collection.)

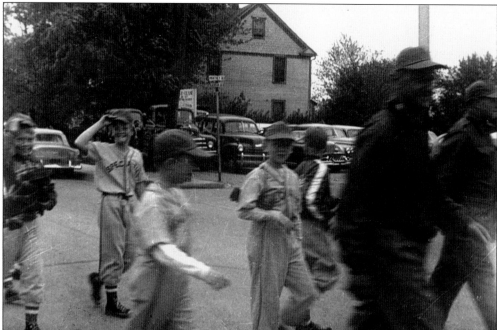

In the spring of 1953, Frank Manarel, Syosset School principal, made sure each Syosset boy aged 8 to 12 received a Little League registration card to bring home. The Lions Club, of which he was the first president, led the establishment of the Syosset Little League. Each season opened with a parade through town. In 1954, John Delin and Chip Harrison are tipping their caps; coach Ted Pearse and manager Fred Bolk, far right, lead their Specialties Incorporated club. (Author's collection.)

Children's birthday parties in mid-20th-century Syosset were mostly held at home as was David Land's, about 1955. Shown in front is Gregory Land; in back is David. On the left side from the front are Sandi Gay, Pete Eriksen, John Delin, and Suzanne Harless. On the right side from the front are Bruce Pecheur, Gary Zabel, Annita Harless, and Steve Zajac. Bruce Pecheur graduated from Syosset High School in 1960 after being voted "Most Popular," "Most All-Around," "Did the Most for the School," and "Nicest Smile." He graduated from Harvard University and achieved success as a men's fashion model and movie actor. He was killed in New York City in 1973 by an intruder while successfully defending his wife and child. The burglar died also. (Author's collection.)

Florence C. Wencko Kwiatkowski sits next to the goldfish pond in her yard at 68 Church Street from around the 1950s. In the background is Leventritt's field. Often his horses would push over the fence to drink from the goldfish pond. Eventually the fence was reinforced. The $13,500 house and land in 1951 were sold for over $250,000 in 1987. (Courtesy of Florence Kwiatkowski Sendrowski.)

DEDICATION OF

THE CHURCH OF

St. Edward the Confessor

JUNE 12, 1955

Syosset, New York

After the parish was established in 1952, St. Edward the Confessor's congregation attended holy mass in the former Syosset Fire Department building on Muttontown Road. The first high mass was celebrated in the newly built church on Jackson Avenue on Christmas Eve 1954. The solemn dedication of St. Edward the Confessor Roman Catholic Church occurred on June 12, 1955. The first pastor was Fr. Edward Hanrahan. The celebrant was the Reverend Charles E. Bermingham, later a monsignor, whose family had developed much of downtown Syosset. (Courtesy of Mary Wencko Gaida.)

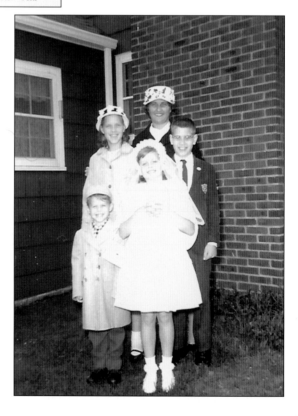

Her father, Edward McAuliffe, took this photograph of Eileen of 11 Meadowbrook Road in the forefront with her mother and siblings. She had just received her First Holy Communion at St. Edward the Confessor Roman Catholic Church on May 8, 1965. Her mother, Mary, and Maureen, Gordon (right), and Michael smile joyfully. (Courtesy of Maureen McAuliffe Smith.)

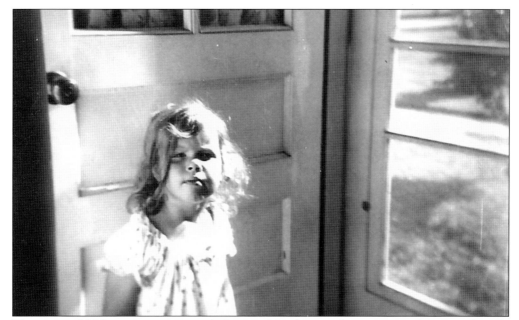

Three-year-old Maureen gazes seriously but confidently into the camera as she nears the side door of her 11 Meadowbrook Road home in 1957, on her way outside to play. (Courtesy of Maureen McAuliffe Smith.)

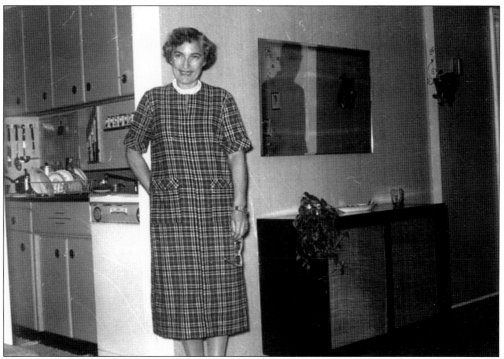

Count Hubert James Marcel Taffin de Givenchy designed the "sack" dress in 1957. Gurli Delin is wearing one in 1958 as the style became popular in America. A top 40 song, "No Chemise Please," mocked it; women liked it, and men hated it. Note another 1950s feature in her kitchen, a washing machine installed beneath the sink. (Author's collection.)

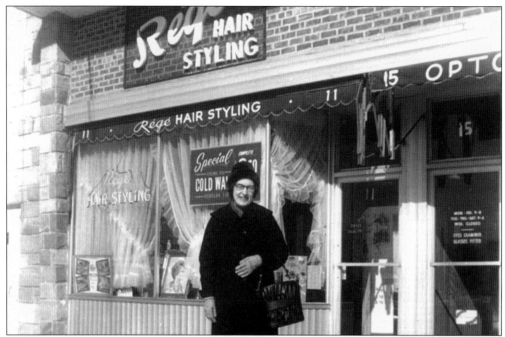

Most Syosset women and girls in the 1950s and 1960s had their hair done at Rege Hair Styling, 11 Ira Road. Gurli Delin had just paid a visit when her husband snapped this picture, around the early 1960s. A "Hollywood Permanent" was priced at $5 while a shampoo and style set was $2. (Author's collection.)

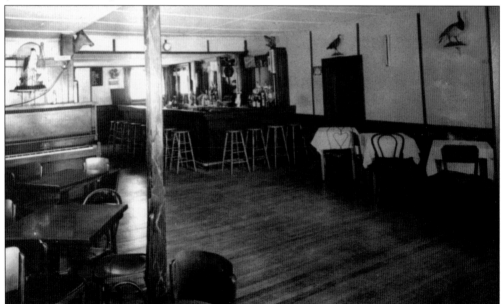

Here is a look inside Kyle and Moran's Inn in the late 1950s. Located on the former site of May's Corner general store at Jackson Avenue and Convent Road, it was founded by Cornelius and Peg Moran in 1940 and called the Syosset Inn. Peg's brother Ernie Kyle partnered with them in 1944, and it became Moran and Kyle's. The original structure burned down in 1953, and its replacement became Kyle and Moran's after Connie Moran died in 1957. (Courtesy of Tom Montalbano.)

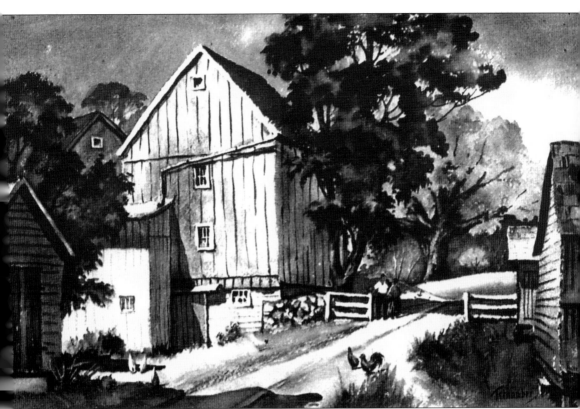

Arthur S. and Harry Underhill successfully farmed in Syosset into the 1950s. Their extensive property once belonged to the Willis family; their mother was the former Henrietta Willis. The Underhill Farm is shown in the above painting by Helmuth Tschamber (reproduced as part of a 1958 Dime Savings Bank Calendar). After the farm's demise, one of its barns was moved to the Old Bethpage Village Restoration. For many years, Willis Avenue and Underhill Lane extended from Jackson Avenue and wound around through the Underhill Farm to Jericho Turnpike. As the population increased, this scenic and bicycle-friendly (but lengthy) route became impractical as another way to go back and forth from downtown Syosset to the turnpike. Underhill Boulevard was the solution to this problem. Although it housed corporations such as Singer and Crest, it also became a local drag strip. (Author's collection.)

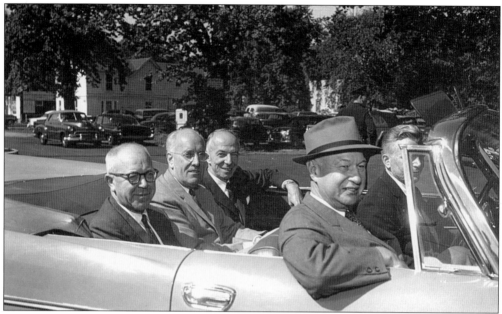

The new, wide Underhill Boulevard began at Jackson Avenue, intersected Willis Lane, and replaced the remainder of it. The ribbon-cutting ceremony for Underhill Boulevard was on September 29, 1958. Arriving in a convertible are A. Holly Patterson (Nassau County executive), in front, and in back shown from left to right are John C. Schulz (chamber of commerce president), Lewis Waters (former Town of Oyster Bay supervisor), and John J. Burns (Town of Oyster Bay supervisor). (Author's collection.)

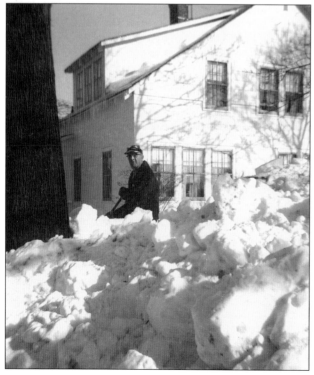

William L. Knettel of 83 Cold Spring Road does not seem overwhelmed, despite the mountain of snow he is facing, as he digs out from the blizzard of February 3–4, 1961. It followed the "Kennedy Inaugural" snowstorm of January 20–21. Two to three feet of snow fell in the area. (Courtesy of Diane Oley.)

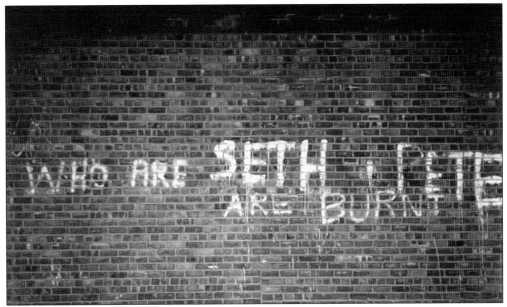

Around 1963, Andrea Anderson and Barbara Kneffing wrote the curious "Seth + Pete" graffiti on the Ira Road wall of the Peak Sweet Shop on Jackson Avenue. "Forever," "Who Are," and "Are Burnt" were added in subsequent years by persons unknown. "Seth" was Seth Bier, a biker who lived fast and died young. "Pete" was Peter Ziegler, alive and well into the 21st century. The statements were finally erased in 1997. (Courtesy of Tom Montalbano.)

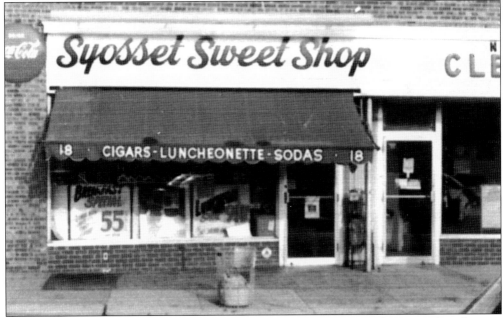

The Syosset Sweet Shop at 18 Cold Spring Road dated back to the early 1950s when the post office was next door at No. 20. Pictured in 1963 when it was owned by Carl and Clara Haas, its neighbor was the Syosset Library. The Syosset Sweet Shop, as its name denotes, had a large loft candy display and sold newspapers, magazines, and cards, as well as sweets. It was also a luncheonette. (Courtesy of Caren Haas Ballantine.)

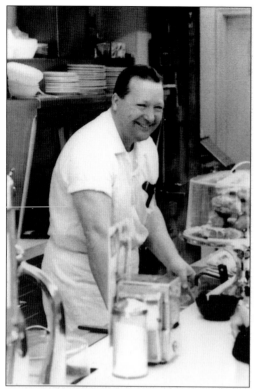

Carl Haas, pictured behind the luncheonette counter, and Clara Haas owned the shop for 10 years, and it prospered under their direction. Customers could sit at the counter or be served in booths located along the side. High school students worked there part time and learned to be short-order cooks. It typified the mom-and-pop shop. (Courtesy of Caren Haas Ballantine.)

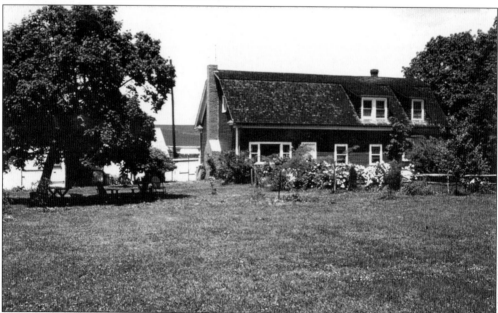

Vincent and Solveig Holm lived in this spacious house at 9 Ryan Street, off Berry Hill Road, from 1947 to 1966. Their children both attended the Syosset Public school; Robert graduated from Oyster Bay High School, while Barbara became a graduate of the new Syosset High School. There was a chicken coop and barn behind the large maple tree. When they sold their property, four houses were constructed on the lot, but the original house remained. (Courtesy of Robert Holm.)

# *Three*

# LIFE (AND DEATH) ON AREA ESTATES

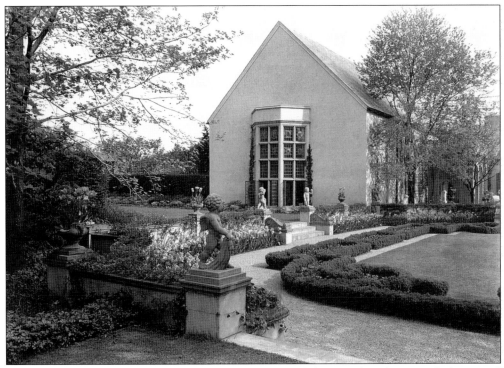

Two and four-tenths of a mile from 9 Ryan Street stood the Woodward Estate Playhouse, off Berry Hill Road. It was once part of Sunken Orchard, the McCann estate, shown on May 9, 1936. This house became the country home of William (Billy) Woodward Jr. and Ann Crowell Woodward. On October 30, 1955, Ann killed Billy in a tragic accident. A grand jury found that the shooting was unintentional. (Courtesy of the Library of Congress, Prints and Photographs Division, Gottscho-Schleisner Collection.)

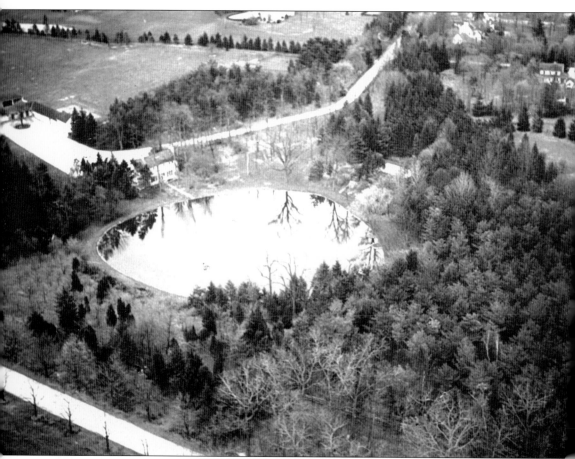

Thistleton, the summer estate of Robert Elliot Tod (1867–1944), was located on what became Burtis Lane. It encompassed 72 acres at the time of this 1945 aerial view. Tod was a financier and the commissioner of immigration for the port of New York from 1921 to 1923. He established his Syosset estate around 1918. Tod was a man of action. In 1903 Manhattan, he witnessed a cab driver running down a woman and her child. He chased the man, confronted him, and "persuaded" him to surrender to the authorities. He became a highly decorated veteran of World War I, and the French government gave him their highest civilian award. Tod asked to serve his country again in World War II, but he was considered too old. He persisted in his efforts to no avail. On November 9, 1944, he fatally shot himself in his bedroom just as his daughter, Katharine, was approaching his door. (Author's collection.)

Robert Elliot Tod married the former Katharine Alexander Chew (1883–1969) in 1904; their daughter was Katharine, known as Kay. Kay had two daughters from her first marriage to Henry Bradley Martin, Cornelia Anne Bradley, known as Anne, and Helen. Shown around 1938 are, from left to right, Katharine, Robert, and Kay, with Anne (left) and Helen in front. (Courtesy of Caroline Nowak Zgutowicz.)

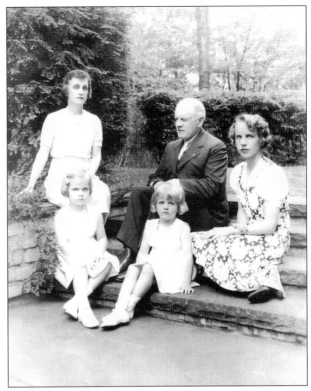

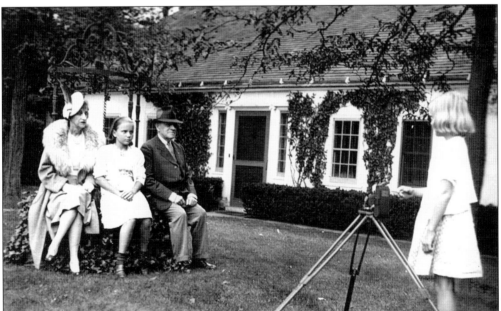

Tod's well was always an excellent spot for a photograph opportunity. Helen is taking a picture of her sister Anne and grandparents, around 1938. After her divorce, Kay later married, in 1949, Maj. Hon. Bartholemew Pleydell-Bouverie, son of the English peer, the sixth Earl of Radnor, and they lived in her estate off Route 25A in Oyster Bay Cove, not far from Katharine's domain. (Courtesy of Caroline Nowak Zgutowicz.)

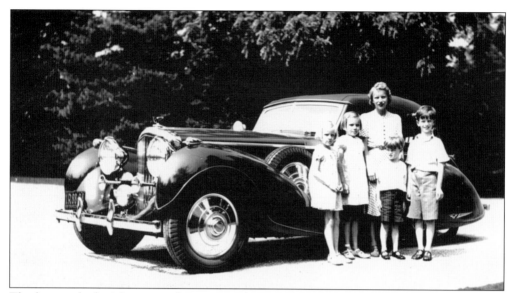

The boys with the Martins in this *c.* 1939 photograph are Tod cousins from England, Oliver Fox-Pitt and his younger brother Mervyn. The automobile is a 1938 Derby Bentley. They spent the war years living with the Tods. Their father, Gen. Billy Fox-Pitt, was the military attaché to King George VI. Oliver's son became England's top-ranked three-day-event equestrian. Mervyn married a sister of the Earl of Dundee, and their daughter became the wife of Lord Moncrieffe. (Courtesy of Caroline Nowak Zgutowicz.)

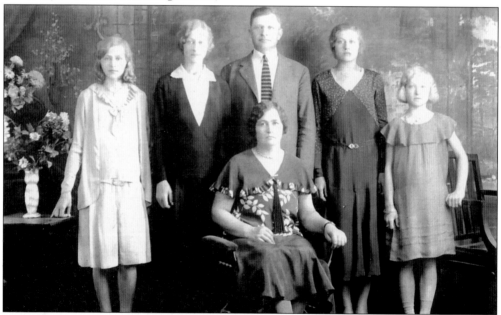

Thomas Nowak and Aniela Madjeski emigrated from Poland. They married in 1913 and lived on the East-Norwich Jericho Road not far from Pres. Theodore Roosevelt's Sagamore Hill. Thomas supported his family as a farm laborer. By 1920, they had moved to the Robert Tod estate. Thomas became the superintendent, and their youngest daughter Caroline was born there. Pictured in 1930 standing from left to right are Agnes, Stella, Thomas, Nell, and Caroline. Aniela is seated. (Author's collection.)

Nell Nowak is about to dive into Tod's luxurious pool, around the late 1930s. Or is she just posing? The picture was taken by her future husband, Robert Boslet. The pool was designed by the noted architects William Adams Delano and Chester Holmes Aldrich and was used by family, guests, and staff alike. (Author's collection.)

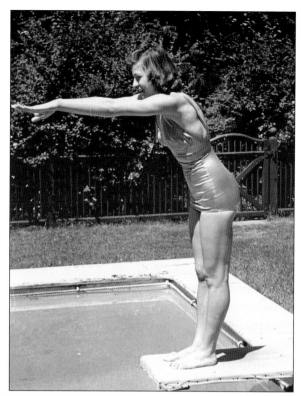

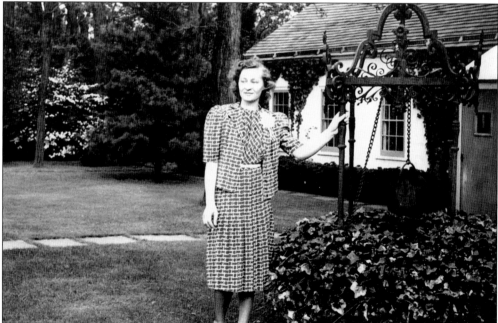

Stella Nowak Berg is standing by the venerable Tod's well on her birthday around 1945. The well in front of the house, with its characteristic "old oaken bucket," was not used to draw water; it was only decorative. Tod's Pond was in back of the house. It had boat docks and was a favorite place for ice-skating in the cold Syosset winters. (Courtesy of Caroline Nowak Zgutowicz.)

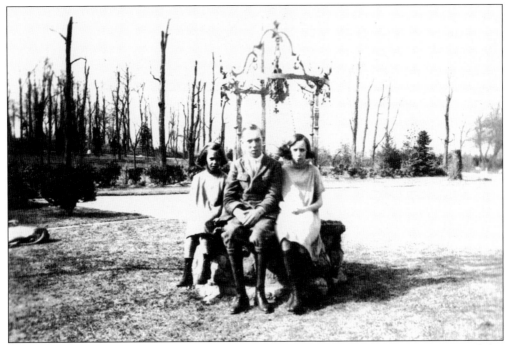

John Richard Greenway, born 1878, emigrated from England to Vermont around 1914 with his wife, Clara, and children Reginald and Eleanor. Ethel Greenway was born there in 1917. After the family settled in Syosset, around 1920, and John went to work on the Tod estate, Mildred was born in 1926. Ethel, Reginald, and Eleanor are seated on Tod's well around 1924. (Courtesy of Lois Ann Greenway Helser.)

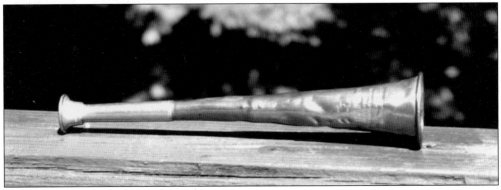

John brought this horn with him from England, and he used it from 1920 to the early 1940s, as the huntsman in the many foxhunts that were held in Syosset. The huntsman is responsible for directing the hounds during the hunt and carries the horn to signal them and the other participants. The Tod estate was a popular field. The Prince of Wales participated in a hunt there in 1924. (Courtesy of Lois Ann Greenway Helser.)

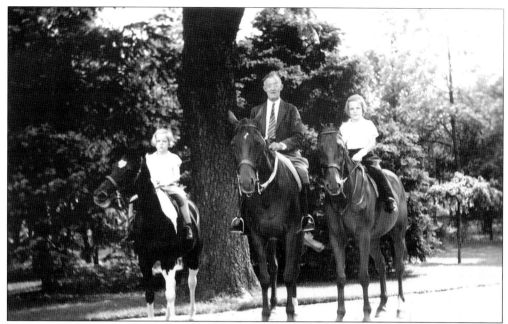

Helen Martin (left) on Jigs, John Greenway, and Anne Martin are riding near the Martin estate gatehouse driveway off Split Rock Road, around 1944. John was an expert horseman and managed Robert Tod's horses and kennels. John also worked for the Martins. He and Clara Greenway lived in the Martin gatehouse. (Courtesy of Lois Ann Greenway Helser.)

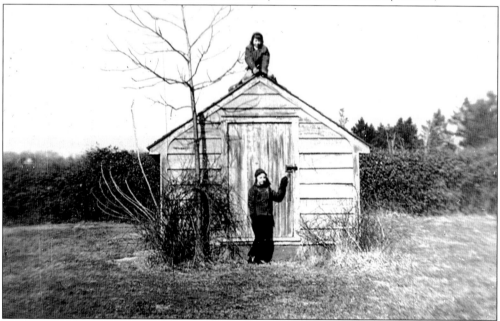

The Nowak and Greenway children and grandchildren spent happy times on the Tod estate, and played and explored the year around. Nell's daughter, Pamela Boslet, was no exception. Like her mother who used to climb the Syosset water tower as a teenager, Pam was a climber. Here she is, at age nine in 1954, atop Tod's pump house (which handled the overflow from the pond and pool). (Courtesy of Caroline Nowak Zgutowicz.)

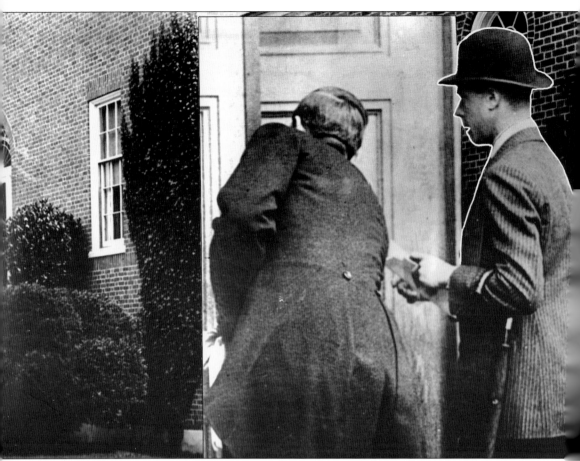

Woodside was the Muttontown Road estate of industrialist James Abercrombie Burden Jr. (1871–1932) and his wife, the former Florence Adele Sloane (1873–1960), a great-granddaughter of Commodore Cornelius Vanderbilt. This unusual photograph is an Elliot Service Company Press wire photograph, dated 1924. It is a composite of Woodside and an informal snapshot made before the Prince of Wales's (far right) visit. The prince was given a golden key to the Burden home where he stayed while attending polo matches at the Meadowbrook Club in Westbury and numerous parties at the local estates. He participated in polo matches and foxhunts as well. Woodside became known as Woodside Acres after Burden died, and his widow later married Richard Montgomery Tobin (1866–1952), banker, philanthropist, and former minister to Holland. The estate became the Woodcrest Country Club. (Author's collection.)

The Prince of Wales, left, ascended to the British throne in 1936 as King Edward VIII, and he abdicated to become the Duke of Windsor. He is chatting with Jerry Frankel, an international news photographer, during his 1924 stay at the Burden estate. The caption (dated January, 21, 1936) taped to the back of this photograph reads, in part, "as the most photographed man in the world, knew considerable about cameras and Frankel was astounded by his technical knowledge." (Author's collection.)

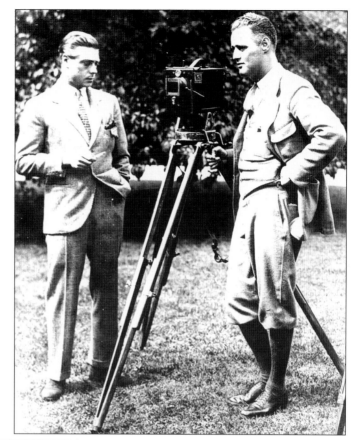

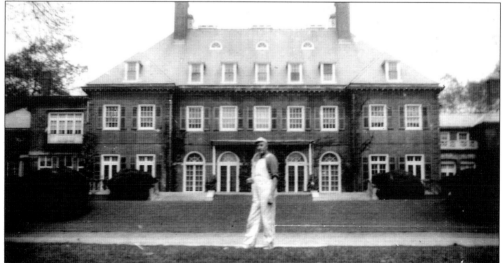

William McAuliffe of Berry Hill Road was the caretaker, in the 1930s, of Fairleigh, the George S. Brewster estate in Muttontown. Brewster (1869–1936) was an heir to the Standard Oil Fortune. The 1914 Georgian-style mansion, designed by Trowbridge and Livingston, became part of the Fox Run Golf and Country Club and later the Hoffman Center Nature Preserve and Wildlife Sanctuary. (Courtesy of Maureen McAuliffe Smith.)

# HE SYOSSET GAME FARM

**Tel. 609**

**Syosset, L. I., New York**

*offers*

## Pheasants

| | | |
|---|---|---|
| ngneck | $ 8.00 | per pair |
| ongolian | 10.00 | per pair |
| ackneck | 12.00 | per pair |
| ver | 18.00 | per pair |
| olden | 20.00 | per pair |
| brid | 25.00 | per pair |
| aleege Melanotus | 25.00 | each |
| dy Amherst | 30.00 | per pair |
| eves | 40.00 | per pair |
| rsi Color | 40.00 | per pair |
| pper Cocks | 50.00 | each |
| een Jungle Fowl | 75.00 | per pair |
| vinhoe | 90.00 | per pair |
| anchurian | 150.00 | per pair |
| ikado | 150.00 | each |
| apeyan, Cocks | 150.00 | each |
| amese Crested | 250.00 | per pair |
| agapan | 250.00 | per pair |

## Cranes

| | | |
|---|---|---|
| rican Crown | $100.00 | each |
| anley | 250.00 | each |

## Turkeys

| | | |
|---|---|---|
| urbon Red | $12.00 | each |
| onze | 12.00 | each |
| olland, Black | 12.00 | each |
| olland, White | 12.00 | each |

## Ducks

| | | |
|---|---|---|
| Rouen | $ 8.00 | per pa |
| Grey Mallard | 10.00 | per t |
| Black Muscovy | 10.00 | per t |
| White Muscovy | 10.00 | per t |
| Pintail | 12.50 | per p |
| Grey Call | 15.00 | per t |
| White Call | 15.00 | per t |
| Black Mallard | 15.00 | per t |
| Fairy Runner | 15.00 | per t |
| Fawn and White Runner | 15.00 | per t |
| Black East India | 15.00 | per t |
| Blue Swedish | 18.00 | per t |
| Cuban Tree | 20.00 | per p |
| Mandarin | 20.00 | each |
| Wood | 25.00 | per p |
| Crested White | 25.00 | per t |
| White Aylesbury | 25.00 | per t |
| Java Tree | 30.00 | each |
| Canvass Back | 30.00 | per p |
| Rosybill Tree | 35.00 | per p |

## Geese

| | | |
|---|---|---|
| White Chinese | $ 7.00 | e |
| Grey African | 8.00 | e |
| Sebastapool | 10.00 | e |
| Canadian | 10.00 | e |
| Egyptian | 12.50 | e |
| Brant | 15.00 | e |
| Blue | 15.00 | e |
| Snow | 20.00 | e |
| White Fronted | 20.00 | |
| Bernicle | 20.00 | |
| Spurwing | 35.00 | |
| Bar Headed | 50.00 | |
| Emperor | 200.00 | |

The Syosset Game Farm, later Woodbury Farms, was located on the Edward Richmond Tinker Jr. estate, Woodbury House, from around 1927 until 1959. It sold turkeys and expensive exotic poultry to both the general public and the estates. Siamese Crested pheasants were $250 a pair. Stanley Cranes were $250 each. The estate was constructed around 1915 for the world-famous left-handed polo player and financier, J. Watson Webb. Samuel J. Wagstaff, a lawyer, bought Woodbury House in 1921 at auction, competing against several other socialites. Tinker later obtained it and remained there until his death. Alfred Boccafola (1911–2001) was the superintendent of Woodbury Farms for many years, and he and his family lived on Tinker's estate. After the estate became the Syosset-Woodbury Community Park, the site of his house became a handball and basketball court. The Boccafola family moved to 8 Newmarket Road. (Author's collection.)

*Four*

# WAR AND
# THE HOME FRONT

Andrew Wencko came to
America from Poland in 1907.
In 1918, to do his part in
support of his new country's
war effort, he became a Third
Liberty Loan subscriber.
Liberty Bonds were war
bonds issued by the federal
government during the Great
War (later named World
War I) to raise needed funds.
The public enthusiastically
rallied behind the government
and loaned it billions of
dollars, which were repaid with
interest. (Courtesy of Florence
Kwiatkowski Sendrowski.)

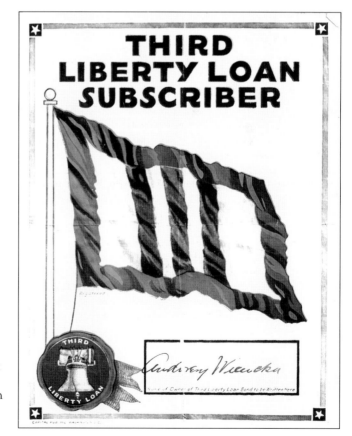

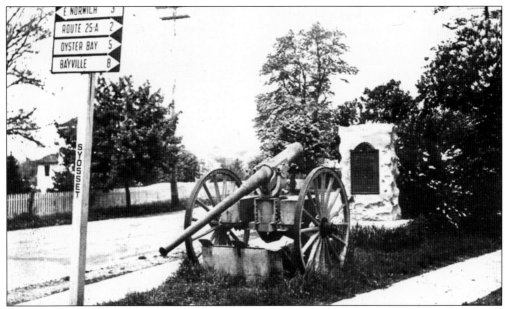

Here is a closer look at the Syosset Memorial Park at the junction of Split Rock and Berry Hill Roads in the late 1930s. In the 1940s, the World War I monument was moved to a new park in the lot next to Weinstock's on Jackson Avenue, and the cannon was sold for scrap metal. Note the old sign pointing out directions and distances to the surrounding towns. (Courtesy of Diane Oley.)

# HONOR ROLL

| | | | | | |
|---|---|---|---|---|---|
| ALLEN, L.M. | ELLIOTT, R. | JOHANSSON, P.O. | MEYER, O.F. | RAGOZZINO, P. | ULMAN, M. |
| ALLEY, R.W. JR. | | JOZWIAK, S. | MICHALOWSKI, S.F. | RAUSCH, G. JR. | URE, J.A. |
| ALLISON, G.G. | | JUSTICE, C.W. | MIDDENDORF, B. | RITCHIE, A.E. | |
| ALLISON, T.S. JR. | FALLON, J.P. | | MINARD, H. | ROBINSON, F. | |
| AMATEIS, H. | FARRELL, J.A. | | MIRON, J.M. | ROOSEVELT, F.D. JR. | |
| ARMSTRONG, J. | FOLEY, J.C. | KAHLER, R.C. | MIRON, M.A. | RUTISHAUSER, E. | VACCHINA, L. |
| ANDREWS, A.P. MCWR | FRIEDRICHS, W.P. | KAISER, R.A. | MIRON, S.C. | RYNSKY, J.C. | VAN COTT, G.A. |
| ANDREWS, A.T. | | KANE, P.J. | MORAN, J.H. | | VAN COTT, J.T. |
| ANTOSYN, E. | | KATOWSKI, F.J. | MORRIS, C.F. | | VAN REES, G.H. |
| ARNDT, O. | GAIDA, G. | KEATING, T.R. | | SARGENT, A. JR. | VERNON, F. |
| | GARLAND, R.L. | KIERNAN, B. | | SANKER, J.J. | VON WOLFFERSDORFF, O.T. |
| | GARVEY, C.J. | KOHLER, H. | | SATCHELL, I.F. JR. | VOORIS, B.B. |
| BAILEY, J. | GELEZEWSKI, V.W. | KOZAK, V. | | SATCHELL, J. | VOORHEST, J.A. |
| BARONE, J. | GENOVA, R.J. | KRISS, C.H. | McAULIFFE, J.J. | SCHIESS, R.A. | VOORHEST, L.R. |
| BASTIANO, A. | GIANNETTA, R.J. | KWIECIEN, P.P. | McKINNEY, D.S. | SCHRAMM, H.H. | |
| BASTON, A. | GLENN, J.W. | | | SCHUMACHER, C.E. | |
| BORODAUCHUK, V. | GORNEY, S. | | | SHEAN, E.T. | |
| BOSLET, D.A. | GRISCOM, B.W. | | NALBACK, P.P. | SIMS, E.M. | |
| BOSLET, J.G. JR. | GUILLE, G. | LADD, D. | NORDQUIST, W. | SLOBODZIAN, J. | |
| BOSLET, R.J. | GUILLE, L. | LANGLEY, J.T. | | SMITH, D.M. | |
| BRAUN, T.W. | GUNTER, W.C. JR. | LANGON, S. | | SMITH, E.B. | |
| BUDD, A.H. | | LANOIR, J. | ODWAZNY, J.J. | SMITH, J.L. | WEIDNER, J.M. |
| BURDEN, J.A. | | LAYTON, W. | ODWAZNY, V. | SMITH, L.I | WEINSTOCK, B. |
| | | LEHMANN, G.J. | OSBORNE, D.W. | SMITH, R.C. JR. | WICKERSHAM, C.W. |
| | HAHN, C.W. | LEUTEMAN, A.H. | | SMITH, W.C. | WILHELM, H.F. |
| CARL, S.F. | HAKKER, R. | LITTLEFIELD, H.N. | | STELLABOTTE, J. | WOOD, G.J. |
| CARNEY, W.P. | HALLETT, J.B. | LORD, D. | PALAMAR, M. | STORTS, W.A. | WOZNIAK, K. |
| CHESARE, P.A. | HALLETT, L.F. JR. | LORD, E.C. II | PATERSON, D. | STROMER, P. | WRIGHT, H.D. |
| CHESHIRE, D.V. | HARRIGAN, W.F. | LORD, F.B. JR. | PATTERSON, D.C. | SUMMERS, R.C.W. | |
| CORCORAN, J.H. | HARRIS, N.K. | LORD, G. DeF. JR. | PELKOWSKI, M. | SUMMERS, S.V. JR. | |
| COX, J.L. | HAVENS, B. | LYON, N.H. | PELL, J.H.G. | SVENINGSON, S.A. | |
| CRAWFORD, G. | HAWXHURST, R.W. | | PEPE, C. | SWINBURNE, L. | |
| CURRAN, H.M. | HECK, G.C. JR. | | PEPE, D. | SZILAGYI, L. | |
| | HENDRICKSON, J.W. | | PEPE, P. JR. | | |
| | HENDRICKSON, R.M. | | PESINKOWSKI, F.J. | TAYLOR, E.P. @ | ZDUNEK, C. |
| DAY, J.F. | HENSLICK, C. | MACKENZIE, I.B. | PESINKOWSKI, T. | TAYLOR, T.S. JR. | ZELANO, J.A. |
| DAVIES, E.F. | HICKS, A.J. | MARTIN, H.B. | POLZIN, J.P. | TERRY, H.B. | ZGLIESEKY, C. |
| DAVIES, R.G. | HINES, J.J. | MARTIN, W.A. JR. | POMPA, B.R. | THIEGARDT, P.P. | |
| DEVERS, C.E. | HODA, J. | MARZOLA, D. | POMPA, O.L. | THOMAS, A. | |
| DEVERS, F.D. | HODA, M. JR. | MASSA, N.A. | POOLE, A. WAC | TIFFANY, D.D. | |
| DeVINE, H.P. JR. | HODA, P. | MATSCHAT, W.F. JR. | PUCCIO, J.A. | TIFFANY, G.S. | |
| DICKEY, M.A. | HODA, W. | MAUTNER, W.J. | PUCCIO, M.J. | TIFFANY, P.J. | |
| DISBROW, J.R. | HORN, K. | MEYER, C.G. JR. | PUCCIO, S.P. | TITUS, G.A. | |
| DITTA, L. | HUNTER, C. | | PUNTON, G.J. | TITUS, S.D. | |

A close-up of the World War II honor roll includes some Syosset residents who died in the service of their country. Clemes Zglieseky had graduated from the Syosset Public School as treasurer of his class and went on to Hicksville High School in the fall of 1936. On November 13, 1942, Clemes Zglieseky, fireman second class United States Naval Reserve, perished on the USS *Juneau* with the five Sullivan brothers and many others. (Author's collection.)

Joseph Boslet Sr.'s son Raymond joined the army on March 30, 1941. Raymond was stationed at Schofield Barracks, just north of Pearl Harbor, on December 7, 1941; his family did not know for several days if he survived the Japanese attack. He then began a 20-year career in the Army Air Force and became a schoolteacher after his retirement from the service. (Author's collection.)

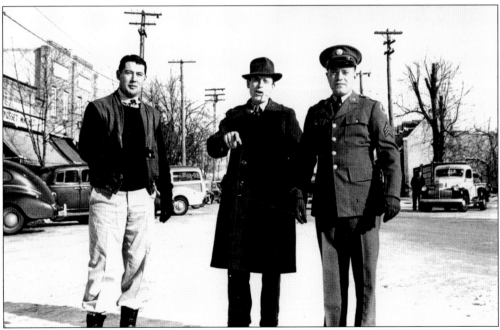

A Syosset soldier on leave waits for a train to take him back to the war. A man who is probably his father is pointing and talking to the cameraman. The Syosset Market is to the left, and, on the right, a truck is parked in front of what soon became the site of the World War I and II memorials on Jackson Avenue. (Author's collection.)

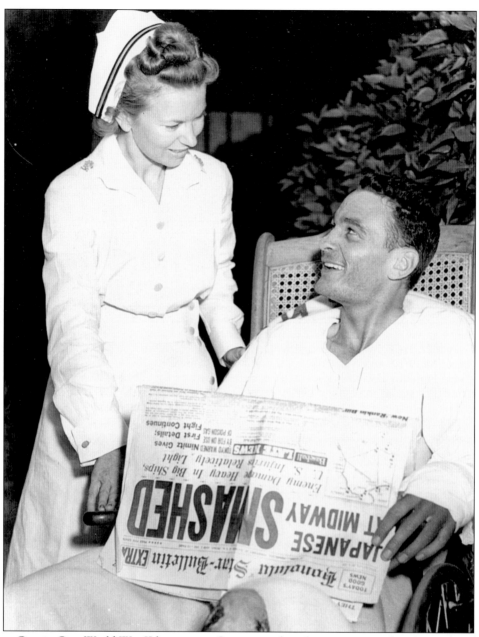

Ens. George Gay, World War II hero, was a Syosset resident for many years when he was a pilot with TWA. He lived at 36 Lilac Drive with his wife, Tess, and daughter Sandi. On June 4, 1942, during the Battle of Midway, his squadron, VT-8, was wiped out after it attacked the Japanese fleet without any protection from U.S. fighter aircraft. Ensign Gay was the only survivor of the 30 pilots and radiomen in that attack. He was wounded, his plane was downed, and he floated for 30 hours in the water, watching the destruction of three Japanese aircraft carriers by subsequent American dive-bombers. In this photograph, he is with a nurse at the Pearl Harbor Naval Hospital. He later received the Navy Cross and the Presidential Unit Citation. Ensign Gay was portrayed by Kevin Dobson in the 1979 motion picture hit *Midway*. (Courtesy of the Navy Historical Center.)

Charles Garvey poses in front of the World War II honor roll on its site next to Weinstock's, on March 27, 1944. Two women are listed. A. P. Andrews served in the Marine Corps Women's Reserve (MCWR), and Amy Poole in the Women's Army Corps (WAC). The honor roll later included Franklin Delano Roosevelt Jr. as an honorary Syosset citizen, after he spoke at the public school graduation in June 1944. Garvey had a long career in the U.S. Navy. He became a chief petty officer. (Author's collection.)

The Krebs and Schulz garage had moved to the northwest corner of Jackson and Whitney Avenues, around 1937. During World War II, the building was leased by Republic Aviation, hence the airplane above the door in this photograph dated April 1944. The sign directly over the door reads "REF Aircraft Corporation." (Author's collection.)

Postmaster Robert Boslet, wearing a Civil Defense armband, is looking to the sky. He was an official Republic Aviation plane spotter. Syosset's Civil Defense personnel scanned the skies with binoculars, using the roof of the former garage as a lookout base. World War II had started with an attack on American soil; a strong Civil Defense presence and volunteer plane spotters were important to the nation's security on the home front. (Author's collection.)

The war effort required great sacrifice on the home front. Food and supplies were scarce, and ration stamps were issued to help ensure that everyone got a fair share. The slogan was "If you don't need it, don't buy it." The above is a war ration book cover. It was issued for 18-month-old Florence Kwiatkowski, then of Split Rock Road. Even the little ones served their country. (Courtesy of Florence Kwiatkowski Sendrowski.)

Leone Knettel Taylor is modeling a genuine Hawaiian grass shirt in her Cold Spring Road backyard in 1945 at the war's end. Her sister Mildred's husband, Forrest Vanstane, stationed there, shipped the souvenir to the "Knettel women" from Hawaii. (Courtesy of Diane Oley.)

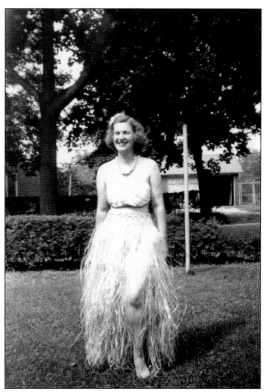

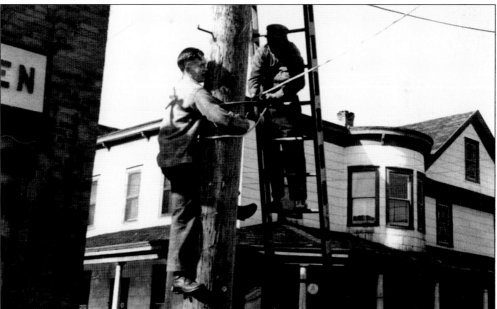

As the World War II veterans were returning in victory, some of those already discharged decided to greet them with a huge banner reading "Welcome Home Donated By Veterans World War II." It was strung from telephone poles and spanned Jackson Avenue with Fred's Barber Shop on the east side. World War II veteran Donald Boslet is on the left as he ties the ropes. (Author's collection.)

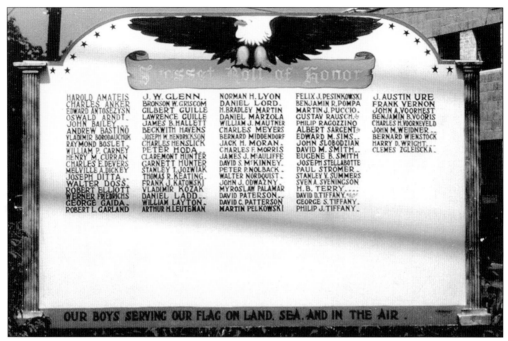

**Syosset Roll of Honor**

| | | | | |
|---|---|---|---|---|
| HAROLD AMATEIS | J. W. GLENN. | NORMAN H. LYON | FELIX J. PESINKOWSKI | J. AUSTIN URE |
| CHARLES ANKER | BRONSON W. GRISCOM | DANIEL LORD. | BENJAMIN R. POMPA | FRANK VERNON |
| EDWARD ANTOSEZYSN | GILBERT GUILLE | H. BRADLEY MARTIN | MARTIN J. PUCCIO. | JOHN A. VOORHEST |
| OSWALD ARNDT. | LAWRENCE GUILLE | DANIEL MARZOLA | GUSTAV RAUSCH. | BENJAMIN B. VOORIS |
| JOHN BAILEY. | JAMES B. MALLETT | WILLIAM J. MAUTNER | PHILIP RAGOZZINO | CHARLES H. VOORNEVELD |
| ANDREW BASTINO | BECKWITH HAVENS | CHARLES MEYERS | ALBERT SARGENT | JOHN M. WEIDNER |
| VLADIMIR BORODAUCHUK | JOSEPH W. HENDRICKSON | BERNARD MIDDENDORF | EDWARD M. SIMS. | BERNARD WIENSTOCK |
| RAYMOND BOSLET. | CHARLES HENSLICK | JACK H. MORAN. | JOHN SLOBODZIAN | HARRY D. WRIGHT. |
| WILLIAM P. CARNEY | PETER HODA | CHARLES F. MORRIS | DAVID M. SMITH. | CLEMES ZGLEBSCKA. |
| HENRY M. CURRAN | CLAREMONT HUNTER | JAMES J. MCAULIFFE | EUGENE B. SMITH | |
| CHARLES E. DEVERS | GARNETT HUNTER | DAVID S. MCKINNEY. | JOSEPH STELLABOTTE | |
| MELVILLE A. DICKEY | STANLEY T. JOZWIAK | PETER P. NOLBACK. | PAUL STROMER. | |
| JOSEPH DITTA | THOMAS R. KEATING. | WALTER NORDQUIST. | STANLEY V. SUMMERS | |
| WALTER DOSS. | FRANK J. KATOWSKI | JOHN J. ODWAZNY | SVEN A. SVENINGSON | |
| ROBERT ELLIOTT | VLADIMIR KOZAK | MYROSLAW PALAMAR | H. B. TERRY. | |
| WERNER FRIEDRICHS | DANIEL LADD. | DAVID PATERSON. | DAVID D. TIFFANY. | |
| GEORGE GAIDA. | WILLIAM LAYTON. | DAVID C. PATTERSON | GEORGE S. TIFFANY. | |
| ROBERT L. GARLAND | ARTHUR H. LEUTEMAN | MARTIN PELKOWSKI | PHILIP J. TIFFANY. | |

**OUR BOYS SERVING OUR FLAG ON LAND, SEA, AND IN THE AIR.**

Before the permanent World War II honor roll was erected by the local Veterans of Foreign Wars, around 1943, this Syosset Roll of Honor for World War II had stood on the southwest corner of Jackson and Whitney Avenues. The Republic Aircraft building is to the right. The full names of "our boys serving our flag on land, sea, and in the air" are listed. (Author's collection.)

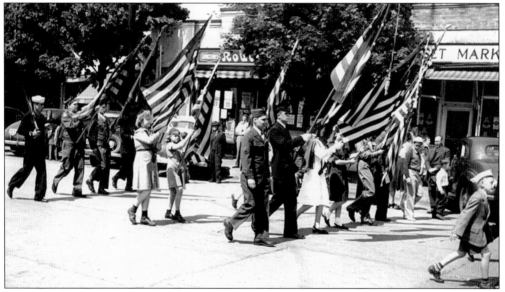

The annual Memorial Day parade in Syosset has continued since the first one on Saturday, May 30, 1942, just before the decisive June victory at Midway started to turn the tide in America's favor. Carrying flags, marchers from all branches of service, scouts, and children pass by Roulston's Grocery and the Syosset Market, headed north on Jackson Avenue, about 1946. The whole town came out to march or watch, and people gathered afterwards to enjoy free refreshments provided by the Veterans of Foreign Wars. (Author's collection.)

*Five*

# DELIVERING THE MAIL

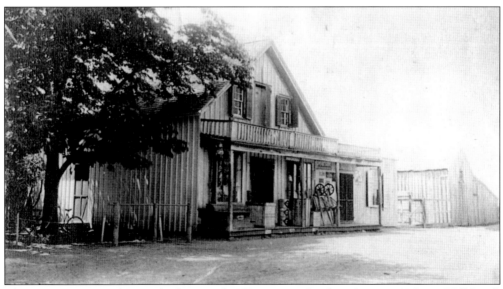

The Van Sise General Store, built around 1857, was on what later became 11 Berry Hill Road. The Syosset Post Office was based there when Charles Alfred Van Sise (1863–1958) was Syosset's postmaster. Charles served from 1892 through 1896 and from 1905 through 1927. His daughter Elsie was his assistant postmaster in the later years. (Courtesy of Tom Montalbano.)

Dec. 3, 1954

National Archives and Records Service
Washington, D. C.

Background Information concerning the Syosset, N. Y. Post Office

Dear Mr. Boslet,

Your letter of November 24, 1954, forwarded to the National Archives and Records Service by the Post Office Department, requested information regarding the post office at Syosset, New York.

According to the records of the Post Office Department, now in our custody, a post office was established at Syosset, Nassau County, (formerly Queens County), on June 15, 1855. Names of postmasters and dates of their appointment were:

| | |
|---|---|
| Philetus Ketcham | June 15, 1855 |
| Cornelius Van Sise | Sept. 16, 1857 |
| John Cooke | Dec. 5, 1867 |
| Charles A. Van Sise | April 28, 1892 |
| John R. DeVine | May 16, 1896 |
| Theodore E. Burtis | Oct. 16, 1900 |
| Raymond E. Cheshire | June 20, 1901 |
| Charles H. Van Sise | Sept. 18, 1905 |
| William Topps | March 1, 1927 |
| Clarence Smith | Jan. 6, 1931 |
| James. A. Devine | March 31, 1936 |
| Robert E. Boslet | April 16, 1940 |

The records do not show when mail was first transported to Syosset by railroad. However, the earliest reference we have found to such mail transportation is located in mail route No. 6046 from Hicksville (via Syosset, Woodbury, Cold Spring Harbor, Huntington, Green Lawn, Centreport, Northport, Saint Johnland, Smithtown, Smithtown Branch, Saint James, Stony Brook, Setauket, and East Setauket) to Port Jefferson, let on October 1, 1877 to the Long Island Railroad Company. 36-1/2 miles and back, twelve times a week for $2,103.15 per annum.

A mail route later including Syosset was No. 1013 from Hicksville (via Syosset, Cold Spring Harbor, Huntington, Centreport, and Northport), to Fresh Pont, was let for the period 1853-57 to Platt Rogers, 17 miles and back, six times a week in 2 horse coaches, for $163.75 per annum.

Very truly yours,

Victor Gondes, Jr. ,
For the Chief Archivist
Industrial Records Branch

In 1954, postmaster Robert Boslet, while researching the history of Syosset's post office as it approached its centennial, sent a letter requesting information to the National Archives and Records Services in Washington D.C. The above letter, dated December 3, 1954, answered his request and included a list of all postmasters and their official dates of appointment from 1855 to 1954. The Syosset Post Office was established on June 15, 1855. Philetus Ketcham, a merchant, was the first postmaster. Cornelius Van Sise, a hotelkeeper, succeeded him in 1857 to 1867. The Reverend John Cooke next served for 25 years. Charles Alfred Van Sise served two terms totaling 25 years. Another notable Syosset resident, Clarence "Dunk" Smith served from 1931 to 1936. The earliest reference that the agency found regarding mail delivery by railroad to Syosset was a route started on October 1, 1877. However an earlier route using two horse coaches was found for the period 1853–1857, which later included Syosset. (Author's collection.)

Postmasters in America had been traditionally chosen based on political affiliation with those in local office at the time. That changed in July 1939 when the federal government started to order competitive examinations for the position. Robert E. Boslet, only 25 years old, a graduate of St. Leonard's Business School in Brooklyn and who was running Boslet's Restaurant with his father and brothers, vied with other residents for the job. Boslet scored the highest in the exam and Pres. Franklin Delano Roosevelt placed his name before the United States Senate where he was confirmed. James A. Farley, United States postmaster general, approved him as Syosset postmaster, March 8, 1940, and he was officially appointed March 21. He poses in front of the post office on Jackson Avenue just after he began serving; below is the badge he carried for the next 33 years. (Author's collection.)

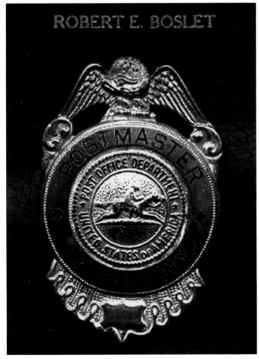

ROBERT E. BOSLET

A building totally dedicated to the Syosset Post Office was erected at 45 Jackson Avenue around 1939. New postmaster Robert E. Boslet is standing in front with some of his staff; Gordon McAuliffe and assistant postmaster Mildred Knettel are on the right. Notice the world's fair poster in the window. (Author's collection.)

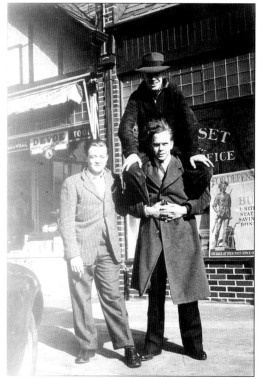

McAuliffe (wearing a hat) and two unidentified friends show off in front of the post office sometime during the early years of World War II. Notice the savings bonds poster in the window on the right. (Author's collection.)

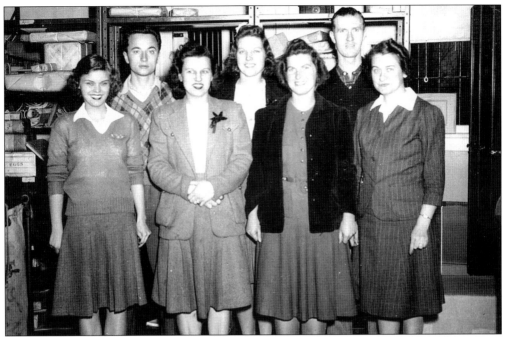

The post office staff celebrates Christmas in 1943. There are lots of packages bound for troops overseas in back of them. From left to right are (first row) Patricia Montgomery, Mary Wencko, Leone Knettel, and Ruth Raplee; (second row) Bernard Middendorf, Mildred Knettel, and postmaster Boslet. (Courtesy of Mary Wencko Gaida.)

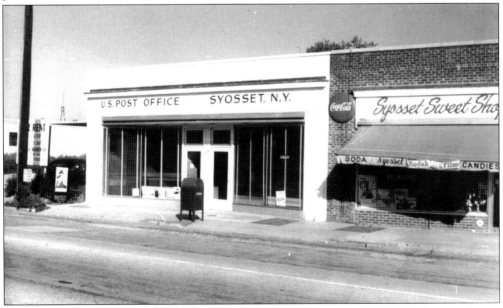

In 1950, the Syosset Post Office, meeting the need to expand after the postwar housing boom, moved to a new location farther east at 20 Cold Spring Road next to the Syosset Sweet Shop. The more spacious post office devoted a whole wall for the display of FBI wanted posters, which captivated a generation of young would-be detectives. There was little or no crime in Syosset but if one of these criminals should show up, the kids were ready. (Author's collection.)

Starting in 1950, people no longer had to visit the post office to receive their mail. Home delivery of mail had begun, mail carriers were hired, and they met the challenge despite cruel snowstorms or even the mid-1950s hurricanes. On July 26, 1950, postmaster Robert E. Boslet tested the new delivery system by mailing a postcard to his five-year-old daughter Pamela (above). It was posted at 10:00 a.m., and Pam received it the same day. The text below instructs her to have her mother give or buy her a Good Humor. The Good Humor ice-cream man in his white truck was a fixture all over America for decades. (Author's collection.)

Syosset, N. Y.
July 26, 1950

Dear Pam,

I hope the mail man brings this to you today. Be a good girl and ask mommy to give you a good Humor, or to buy you one the next time the Good Humor Man comes around. Good Bye for now; see you later.

*Daddy*

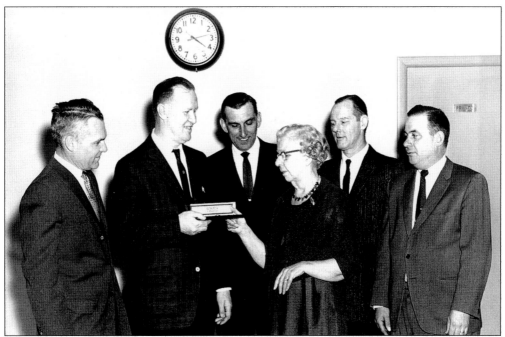

Clarence "Dunk" Smith's sister Edith became a clerk in the post office during the 1920s. She married Albert Frankland Budd, a builder and one of the founders of the Syosset Fire Department. After more than 30 years of service, Edith Budd (1893–1989) retired around 1958. Above, postmaster Boslet is presenting her with a Gruen watch as Vladimir (Archie) Borodavchuk, on Boslet's right and Eddie Lagutski on his left look on with two unidentified employees. (Author's collection.)

After a little more than 10 years in the building at 20 Cold Spring Road, the post office was set to expand again. The post office at 40 Queens Street is shown under construction in 1961. This location has been used into the 21st century. (Author's collection.)

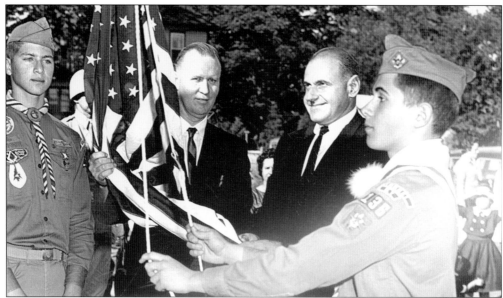

The new Syosset Post Office was dedicated after a parade in the town, culminating in this flag-raising ceremony on September 17, 1961. Pictured are, from left to right, Boy Scout Bruce Chasan, postmaster Robert E. Boslet, congressman Steven B. Derounian, and an unidentified scout. The post office served a wide area. After the zip code system began in 1963, Syosset received the code 11791, as did the incorporated Village of Laurel Hollow and parts of Muttontown and Oyster Bay Cove. Interestingly subdivisions of Syosset including Clearview Landing (on Jericho Turnpike), Landia (an abandoned LIRR station near Robbins Lane), and Little Ipswich (the extinct Chalmers Wood estate in Woodbury) are still, in the 21st century, on the post office list of places using the zip code 11791. (Author's collection.)

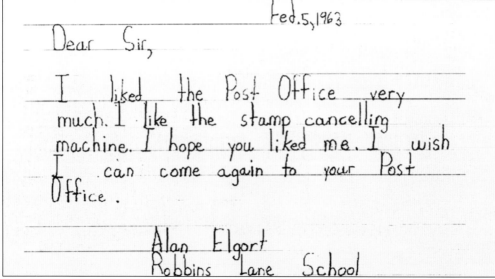

In February 1963, the second-grade students from the Robbins Lane School visited the post office on a field trip and were given a guided and detailed tour by postmaster Boslet. They all sent him thank-you letters and were often specific in describing what they enjoyed most. Alan Elgort's letter is shown above. (Author's collection.)

*Six*

# THE VAMPS, SYOSSET'S BRAVEST

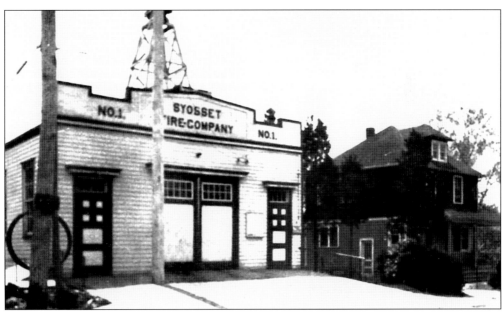

The original Syosset Fire Headquarters on 35 Muttontown Road was built in 1916 by Syosset's volunteer firemen. Fire Company No. 1 had been founded on November 29, 1915. For years, residents, family, and friends battled fires mostly on their own. The founding families convinced residents that it was essential to have a fire department in Syosset. The photograph postcard above pictures the headquarters in the 1930s. (Courtesy of Diane Oley.)

The Syosset Fire District was formed September 7, 1927, by the Town of Oyster Bay. This enabled the fire company to obtain tax money after private donations had sustained it for 12 years. Albert Frankland Budd (1883–1942), former fire chief, was the first chairman of the board of commissioners. (Courtesy of the Syosset Fire District.)

Volunteer firemen are called vamps because they often went to fires on foot, *vamp* being an old English word for "walk." Syosset's first vamps responded quickly to fires and formed bucket brigades to extinguish them. They purchased their first fire truck in 1916, which held two 40-gallon water tanks. William L. Knettel is shown in uniform June 1934. He was one of the founding members of the Syosset Fire Department. (Courtesy of Diane Oley.)

"A fire doesn't . . . know the difference between a volunteer and a professional . . . I consider volunteers in Nassau County to be unpaid professionals because they have so much training," said Joseph Boslet Jr. in 1991. Boslet, shown at home with his son Alan around Christmas 1953, joined the military November 12, 1942, and spent most of the war as an army photographer. After the war, he married and then was urged by his brothers to join them as vamps. Almost jokingly, he replied that he would, when a new fire station was built to replace the original station on Muttontown Road. When the town finally voted approval for the new station on Cold Spring Road, William Rynsky, longtime volunteer, handed Joseph an application, and he joined in 1952. Later he applied for and received a job as inspector in the county fire marshal's office. He worked there for 27 years and retired as the fire marshal of Nassau County. (Author's collection.)

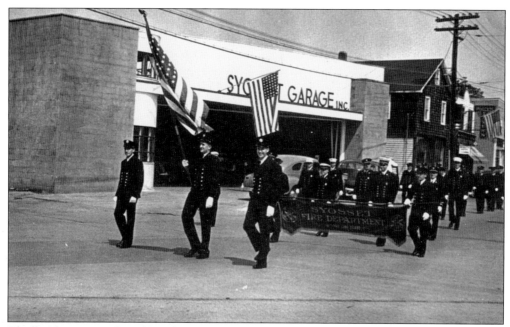

The fire department has always been a major presence in Syosset's Memorial Day parades. Here they march south with flag and banner on Jackson Avenue past Puccio's Tavern and Kreb's and Schulz's Syosset Garage, approaching Whitney Avenue around 1946. The garage was no longer occupied by Republic Aircraft; Charles Krebs and John Schulz were back in business after aiding the war effort. (Author's collection.)

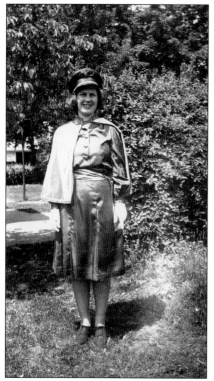

Leone Knettel Taylor is seen in her Syosset Fire Department Ladies Auxiliary uniform in the 1940s. Her husband, Tom Taylor, was Syosset's fire chief for many years. The new headquarters was built across from their home on Cold Spring Road. The Syosset Fire Department Ladies Auxiliary was formed in 1922. (Courtesy of Diane Oley.)

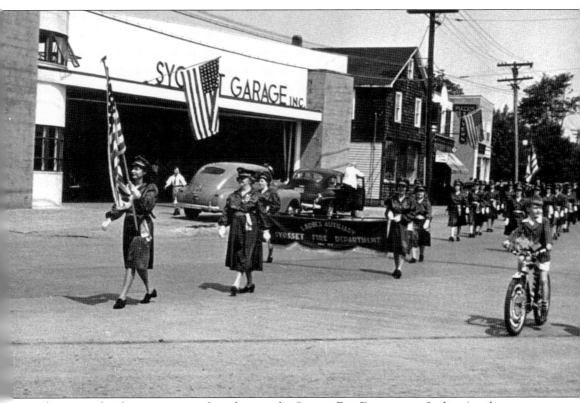

The wives, daughters, sisters, and mothers in the Syosset Fire Department Ladies Auxiliary not only supported the vamps by providing them food and drink at times of fires and emergencies but in raising funds, representing the Syosset Fire Department at town functions, and participating in other community activities. They also marched in uniform in all the Memorial Day and other parades with the fire department, as a separate organization. Flags are hung from the retail businesses as they march with flag and banner on Memorial Day, about 1946. The boy on the right has placed red, white, and blue crepe paper in the spokes of his bicycle wheels as he rides next to the ladies. Children of all ages attended the parades on foot, carrying small American Flags, and on their bikes, which were always decorated. (Author's collection.)

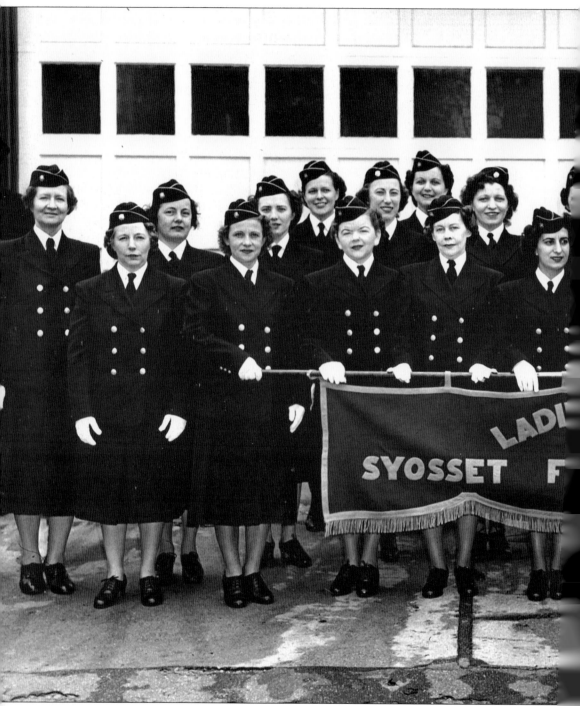

The Syosset Fire Department Ladies Auxiliary poses in full regalia in 1951. This is likely the last group picture taken of the organization in front of the old headquarters on Muttontown Road. Seen are, from left to right, (first row) two unidentified, Jenny Jozwiak Smith, unidentified, Ida Pompa, Josephine Kucinski, Florence Marzola, Frances Hendrickson, Adele Greenway, Rose Golbin, and Ann Rynsky; (second row) Winifred Boslet, Nellie Solnick, Josephine Miron,

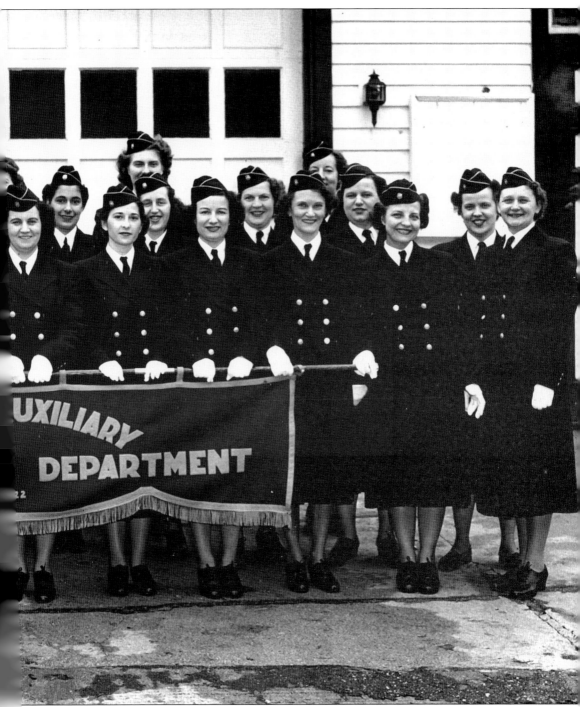

unidentified, Wilma Jozwiak, Ida Poole, unidentified, Margie Katowski, Marion Miron, Mary Wencko, and Joan Puccio; (third row) unidentified, ? Nalback, Bridie Murphy, Irene Arominski, and ? Van Velsor. The old firehouse was still being used as an automobile body shop into the 21st century. (Courtesy of the Wencko family.)

Tournament or drill teams were first formed by fire departments in the early 19th century. Teams competed with teams from other towns in timed events consisting of racing, running hose, manning ladders, pumps, and buckets. Syosset's team was named the Night Raiders as early as 1948 and competed that year in Farmingdale. Vamp Stan "Cement" Kwiatkowski, his son Stan Jr. (known as "Little Cement"), and daughter Florence, are shown around 1956. Night Raider Stan Jr., age 19, has a broken arm after falling from the team's speed wagon. (Courtesy of Florence Kwiatkowski Sendrowski.)

The Night Raiders are pictured in Hicksville, 1984. In 2008, James "Mootsie" Thomas registered 60 years as an active volunteer. He is sitting on the fender. Another longtime vamp, Joseph "Friday" Hendrickson is seated in front of him. Walter Youngs is standing, second from left. The last three men sitting inside the truck on the extreme right are, from left to right Jim Bremen, Frank Steall, and S. Morris. (Courtesy of Patrick Judge.)

On Sunday evening October 24, 1965, a major fire started in a storage building at the Columbia Corrugated Container Corporation on Michael Drive. Tons of waterproof paper went up in flames. The paper would be hosed and catch fire again because of the intense heat. As a result, the raging fire was not declared officially "out" until Friday. The men, who contained and extinguished the stubborn blaze, and the ladies auxiliary, who served them much-needed coffee and refreshments as they fought, were later honored by the Town of Oyster Bay for their valor. (Courtesy of Patrick Judge.)

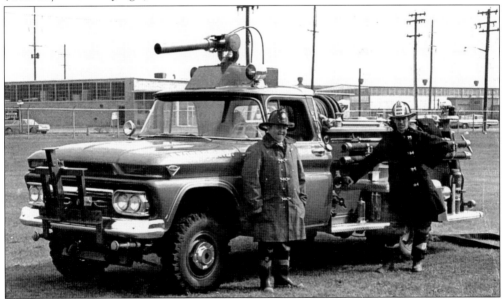

Capt. William Judge was on the first truck at the scene, and his family did not see him for a week. He is pictured (left) with fireman Edward Jozwiak, who worked as the dispatcher for the fire. Here they are on standby, around 1965, at Mitchell Field, Hempstead, with No. 5811, the only truck on Long Island at the time that could pump and move simultaneously. (Courtesy of Patrick Judge.)

At all parades, the fire trucks always follow the vamps. At the Syosset Memorial Day parade, such as this one in 1978, the vamps and trucks are the last to pass, which is a spectacular finish to the procession. Because the volunteers receive no compensation, funds instead are allocated to provide them with first-class trucks and equipment. (Courtesy of Patrick Judge.)

## *Seven*

# SOUTH TO THE TURNPIKE

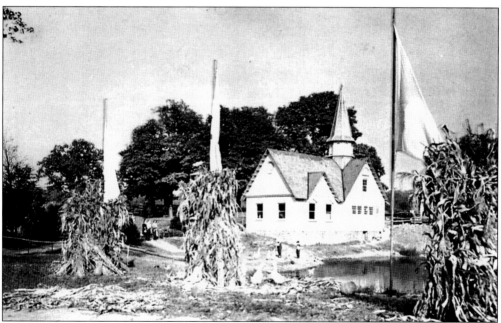

Visitors stroll through the grounds of the late, great Lollipop Farm, decorated with flags, cornstalks, and pumpkins in this autumn scene. Syosset's main attraction for many years, it was a petting zoo on the north side of Jericho Turnpike near Jackson Avenue. Harry Sweeney and his wife, Alice Vee Sweeny, founded and developed Lollipop Farm, and it opened in June 1950. (Author's collection.)

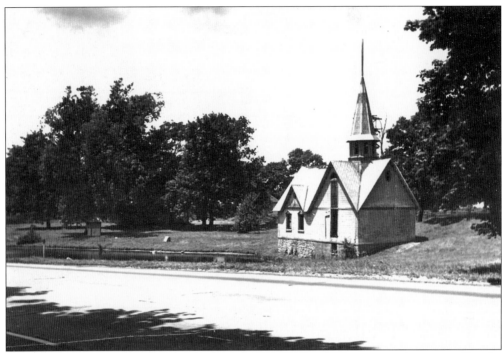

Lollipop Farm was situated on what had been the Martha Jackson property, long owned by the Jacksons and once a stagecoach stop. This old icehouse, shown around 1940, later became the farm's Steeple House. Ice had been cut from the pond in front and stored within the house. The road is Jericho Turnpike. (Courtesy of Maureen McAuliffe Smith.)

Little Diane Vanstane, holding a balloon on a stick, poses on a footpath next to the renovated Steeple House and the pond in 1953. She is also holding a bag with feed for the many ducks that populated the pond. Later she will get a chance to pet and feed the gentle goats, ponies, and other animals. Lollipop Farm closed in 1967. Homes were found for all the animals, and the Sweeneys retired to Pennsylvania. (Courtesy of Diane Oley.)

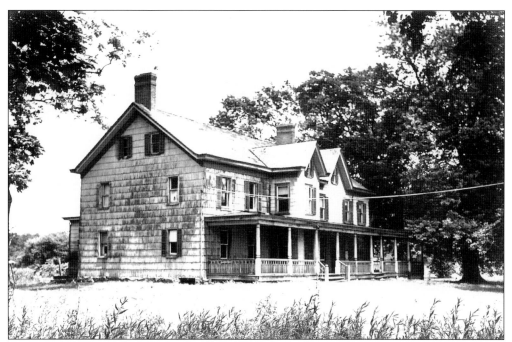

Edward Sieloff, born around 1887, was a truck farmer who leased the Jackson land from about 1930 for many years before it became Lollipop Farm. He lived in this house at Jackson Avenue and Jericho Turnpike with his wife, Margaret, and four daughters. (Courtesy of Maureen McAuliffe Smith.)

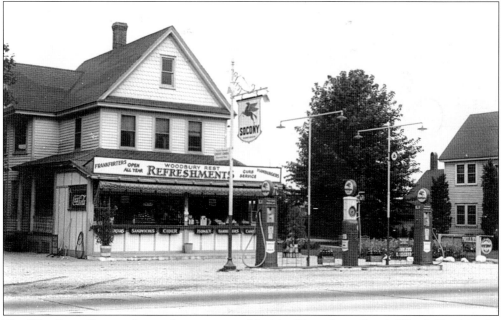

The Woodbury Rest at the northeast corner of Jericho Turnpike at South Woods Road in the mid-1930s was a popular stop along the turnpike. It was also a Standard Oil Company of New York (Socony) gas station. It was open year-round; drivers and passengers received curb service. (Courtesy of Mary Wencko Gaida.)

*Pierre's Restaurant*, telephone Syosset 6-1973, shown around 1940, had been the Restaurant Cordon Rouge. It was a French restaurant owned by Felix and Pierre of Baldwin. It became the Viennese Coach under George Eberhardt. Rustan Lundstrum from Sweden and his son Lennart took it over in 1955, and it was known for years for fine food, continental atmosphere featuring Viennese music, and catered gatherings. It burned down in 1989. (Author's collection.)

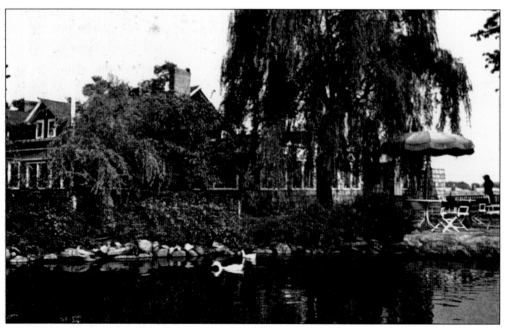

Villa Victor, Frank Zani's French restaurant by a lake on Jericho Turnpike featured the Flagstone Bar and Cocktail Lounge and exclusive dining. It had banquet facilities accommodating up to 400 people. The Island Lodge Motel adjoined the Villa Victor, which eventually became the North Ritz Club. (Author's collection.)

The Maine Maid Inn at 4 Old Jericho Turnpike in Jericho has a long history. It was built in 1789 and became the home of a prominent Quaker and first president of the LIRR, Valentine Hicks, and his family. As of the early 21st century, it was the oldest restaurant on the North Shore of Long Island. (Author's collection.)

Sydney Franklin Van Sise and Flora Isabella May Van Sise were the original owners of Van Sise Farms on Jericho Turnpike and Southwoods Road. Harold Van Sise ran the farm with his father and was also trustee of the Wesley Methodist Episcopal Church, East Norwich. Flora was Theodore May's sister. He and his wife Georgiana operated the May's Corner general store, on Jackson Avenue and Convent Road, from the early 20th century to about 1940. (Author's collection.)

The Mah Jong Restaurant, owned by Peter and Nellie Chinn, and Peter and Susan Yee's restaurant were popular spots to enjoy Chinese cuisine in the 1970s. The Mah Jong Restaurant was advertised as Long Island's leading Chinese-Polynesian restaurant. It featured an Aloha Room for South Seas dining. Exotic cocktails were served in the Bamboo Lounge. It had an open-air patio and art garden. The Mah Jong Restaurant offered Hawaiian entertainment on weekends and a luau "table of plenty" on Wednesdays. (Author's collection.)

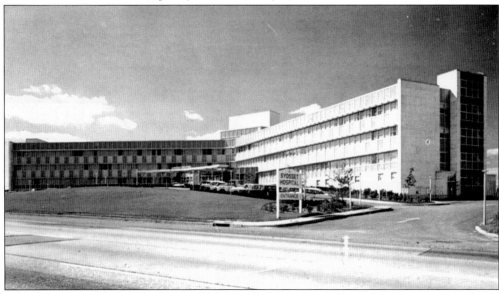

Before the Syosset Community Hospital was built at 221 Jericho Turnpike across from Villa Victor, residents had to travel to Huntington and Glen Cove for treatment and for their children to be born in a hospital. It later became part of the North Shore Long Island Jewish Health System. (Author's collection.)

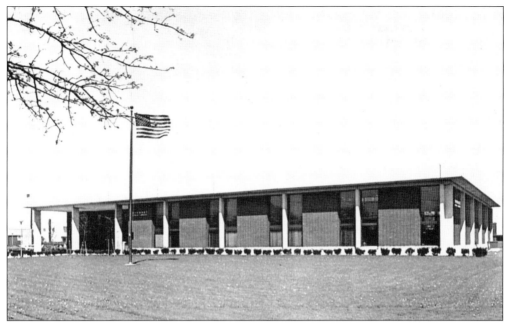

Prior to 1958, except for a time when Weinstock's stationery store helped with a small circulating library, residents had to travel to Oyster Bay to borrow books. From 1958 to 1961, the Kiwanis Community Library at 14 Roosevelt Avenue served as Syosset's library. The Syosset Public Library was formed in 1961 and rented the former post office at 20 Cold Spring Road until 1963, when it relocated to 29 Jackson Avenue, the former site of the Hempstead Bank. The modern-day Syosset Public Library on South Oyster Bay Road opened in 1970 and is shown around the 1970s. (Author's collection.)

This is the cover of a technical handbook issued by Specialties Incorporated, "Skunks Misery Road, Syosset, L. I. N. Y." That road never existed in Syosset. Specialties Incorporated was originally based in Lattingtown at that location. The company, which manufactured flight instruments, among other things, moved to Syosset and maintained this unique address. It was really on Jericho Turnpike in the industrial area. Specialties Incorporated was one of the four team sponsors in the Syosset Little League in 1953; the others were the Lions Club, the Veterans of Foreign Wars, and the Fairchild Corporation. (Author's collection.)

# SKOURAS THEATRES CORPORATION

*proudly presents*

## THE MOST MODERN and LUXURIOUS
## THEATRE IN THE COUNTRY

ENTIRE PROCEEDS OF THIS GALA PREMIERE
BENEFIT OF UNITED SYOSSET AID

•

TUESDAY EVENING, NOVEMBER 20, 1956
8:30 P. M.

The Syosset Theatre opened November 20, 1956; it reopened June 26, 1959, as the first purposely built 70 millimeter Cinerama theater in America. It had 1,450 seats, an 18-meter screen, and Ashcraft Super Cinex arcs. The theater closed and was torn down in the early 1990s. (Author's collection.)

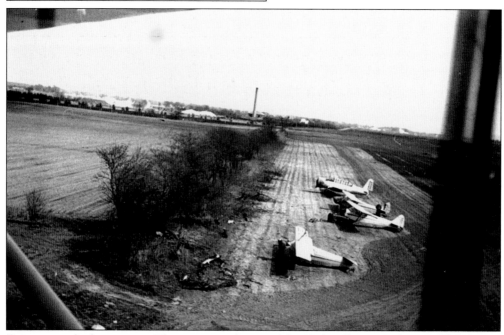

Syosset once had an airport. This is an aerial view of the Hicksville Air Park on Robbins Lane, 1947. Bob Boslet took this photograph from a plane flown out of this airport. It was founded by George Spohrer and functioned from 1945 to 1949. Flying lessons were provided by World War II veterans. The site is now an industrial park on Aerial Way. (Author's collection.)

*Eight*

# EDUCATION

## TRUSTEES' ANNUAL REPORT.

**Report** of the Trustees of *Syosset* School District No. *12* in the Town

of *Oyster Bay* for the School year ending with July 25, 1893,

to *S. S. Surdam* School Commissioner of the

Commissioner District of the County of *Queens*

STATE OF NEW YORK.

**Department of Public Instruction,**

SUPERINTENDENT'S OFFICE,

*Albany, N. Y., July 1, 1893.*

The one-room Syosset School, district No. 12, was located at what later became Split Rock Road and School House Lane. The Syosset Trustees' Annual Report, for the school year ending July 25, 1893, records that the state provided $142.66 in 1892–1893 to pay the only teacher, Louise Newman, for 42 weeks work, and allocated 66¢ for the library. (Courtesy of the Author and Tom Montalbano.)

Elsie May Van Sise passed the eighth-grade exam in 1904, received this certificate, and was therefore qualified to continue her education. Her teacher, Conrad Otto Schweitzer (1882–1976), was only 21 when he taught in the one-room schoolhouse. He later moved to New Jersey where he became principal of Public School 8 in Passaic. (Author's collection.)

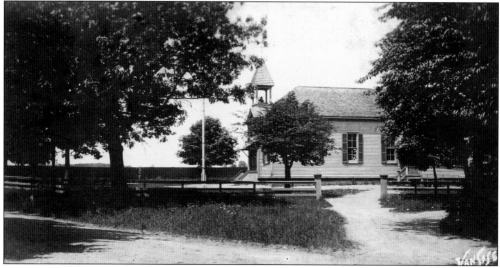

This two-room wooden building at the same location supplanted the one-room structure around 1905. After it was replaced in 1925, it was used for after-school organizational meetings and storage until around 1936, when it was destroyed by fire. (Courtesy of the Syosset Public Library local history room.)

The school underwent subsequent renovation and improvement in an attempt to keep up with the times and increase in students. In this group, 1924, LeRoy E. Budd is in the first row, third from left, and Nellie Nowak is in the third row, fourth from left. (Author's collection.)

In 1919, the state declared that the school no longer met its requirements. While a new school was being considered and built, the firehouse on Muttontown Road was used for the younger children from 1919 to 1925. In this 1924 photograph, identified in the first row are Charles Devers (third from left), Stanley "Sonny" Gurny (fifth from left), Archie Borodavchuk (third from right), and ? Puccio (second from right); (second row) Elizabeth Bayles (third from left), Blossom McKinley (fourth from left), Anne Bailey (fifth from left), Hazel Topps (second from right), and Florence Marzola (right); (third row) George Hillsdon (second from left), Phyllis Bromley (sixth from left), Mary Zimmer (eighth from left), Anne Cheshire (ninth from left), Florence Wencko (seventh from right), Mary Bilensky (sixth from right), Jennie (Cookie) Kobusky (fourth from right), and Mary Wencko (second from right); (fourth row) Katheryn Merchant (teacher, left) and George Gaida (second from left). (Courtesy of Mary Wencko Gaida.)

Caroline Nowak is happy at her desk, around 1928, in the new Syosset School, built in 1925 and dedicated January 15, 1926. The approximately four acres of land cost $9,500, and the school cost $210,899. (Courtesy of Caroline Nowak Zgutowicz.)

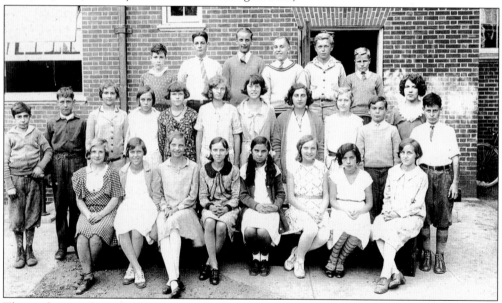

The graduating class of 1932 is pictured. The teacher was Elinor R. Kilgallon, who later became Mrs. Hefner. She was with the school when it opened and served until her retirement. From left to right are (first row) Stella Rynsky, Helen Grazis, Pauline Zglieseky, Anna Slobodzian, Rose Giannotti, Cecilia Kuskowski, Antoinette Stellabotte, and Marjorie Katowski; (second row) Henry Marzola, Frank Katowski, Gertrude Manelski, Ethel Greenway, Dorothy Van Sise, Olga Bailey, Tessie Slovinski, Frances Mann, Agnes Nowak, Melville Dickey, and Austin Ure; (third row) Jack MacDonald, William Brown, Gus Kleiss, Albert Juransky, Myroslaw "Maurice" Palamar, and Jack Rutherford. (Courtesy of Lois Ann Greenway Helser.)

The Syosset School, pictured around the 1940s, had 2 stories and 10 classrooms. Gym classes featuring intramural sports and exercise were held indoors in the gymnasium. All classes attended assemblies in the auditorium, which had a well-equipped stage for student-performed plays. On the grounds were a playground with a merry-go-round and first one, then two, ball fields, used in gym classes, recess and for the newly formed Little League (in 1953). (Courtesy of Diane Oley.)

Charles "Dusty" DeMilt was a longtime stationary engineer and custodian of the Syosset School. He is shown looking out the window at a picnic in Bayville, August 1941. From left to right are (first row) Leone Knettel Taylor and Edith "Poncey" Webb; (second row) Mildred Knettel, Dot Van Sise, and Charles's daughter Florence "Tot" DeMilt. (Courtesy of Diane Oley.)

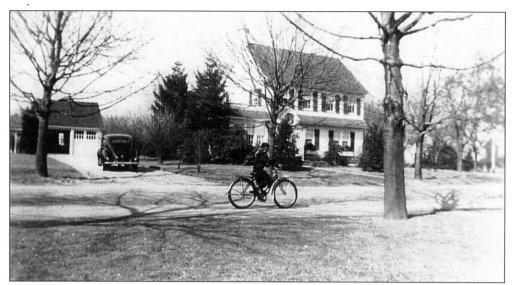

Above Sally Anne Lynch is riding her bicycle back to school after lunch, around 1943. She is passing the home of Howard and Cecilia (Horan) Kreutzer at 16 Church Street. Howard was, as well as a Bank of Syosset director, the chairman of the board of the Jericho Water District for many years. There is a prewar Lincoln Zephyr in the driveway. Below is Sally's father's Berry Hill Service Station near the railroad. Daniel X. Lynch was a longtime member of the Syosset School Board. (Courtesy of Sally Anne Lynch.)

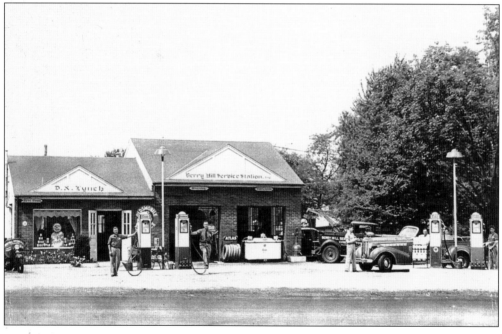

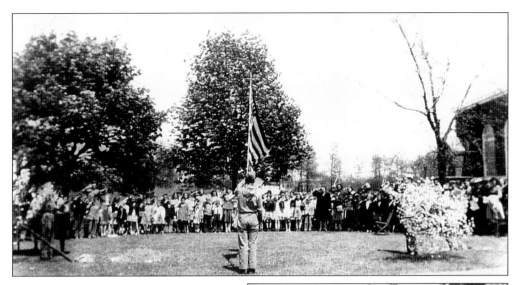

Julius Sterling Morton started the first Arbor Day in Nebraska, 1872. In the 19th century, Arbor Day at Syosset School No. 12 was always celebrated on the Friday following May 1. The 1893 trustees reported that six trees were planted that day. The tradition continued in the 20th century, usually on the last Friday in April, and was particularly emphasized by principal Frank Manarel during his long and distinguished service. Above the whole school watches the Arbor Day ceremony in 1947. Trees were planted in memory of Daniel Lynch and Charles DeMilt, who had both died in 1946. At right is the tree planted for Daniel. (Courtesy of Sally Anne Lynch.)

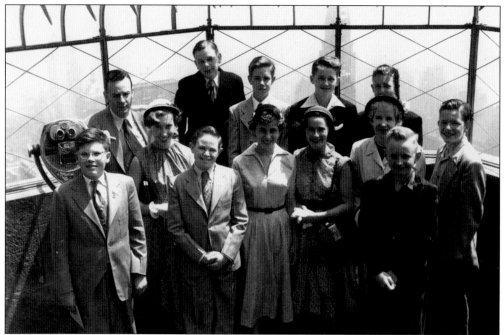

Another of Frank Manarel's many contributions to the Syosset School was the annual eighth-grade class trip to New York City. The graduating class of 1952 is shown atop the Empire State Building in the spring. From left to right are (first row) Bob Hammond, Janet Day, Peter Kahn, Monica Rumpf, Maria Maimone, Elinor Hefner, Dave Rowntree, and Dick Storz; (second row) Frank Manarel, Stan Kwiatkowski, Royall "Mike" Victor III, Bob Holm, and John Burckley. (Courtesy of Robert Holm.)

With the formation of Central School District No. 2 and its new schools, Syosset School became known, by its location, as the Split Rock School. After nearly 60 years of existence, the beloved edifice was torn down in 1984, despite protests by residents, to make way for upscale housing. All that is left is a "Field of Dreams." The ball field was still utilized into the 21st century by the Little League for its youngest participants. (Author's collection.)

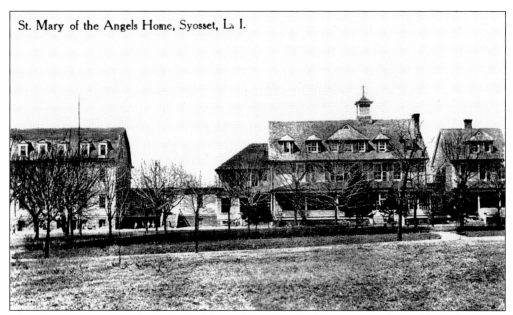

St. Mary of the Angels Home, Syosset, L. I.

This is an early postcard of the St. Mary of the Angels Home on Convent Road. Catherine McAuley founded the Sisters of Mercy in 1831. The Sisters of Mercy were dedicated to improving the lives of disadvantaged people. In 1894, after purchasing 120 acres of farmland, they established St. Mary of the Angels Home. Originally a summer retreat, the home soon became a place where orphaned boys were housed, lovingly cared for, and educated. (Author's collection.)

Our Lady of Mercy Academy, just east of St. Mary of the Angels Home on Convent Road, was established in 1928 by the Sisters of Mercy. The main entrance originally faced Syosset-Woodbury Road. In time, the back entrance facing Convent Road became the main entrance. The Colonial tower is 117 feet high. The academy was originally a boarding school for girls in grades 1 through 12 and eventually became a high school including more day students. (Author's collection.)

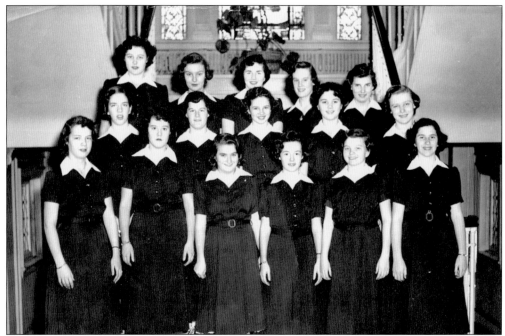

Here are some of Our Lady of Mercy Academy's juniors in 1956–1957. The girls who signed the back of this photograph are Margaret E. Acosta, Linda Alchermes, Jane Barnes, Judy Barnes, Barbara Brady, Dolores Francis, Marilyn J. Gaita, Arlene Gandolf, Gail Gilmartin, Pat Gurnick, Mary Henkemeier, Mary E. Herrick, Pat McElroy, Mary Jane McManus, Barbara O'Connor, and Kathie Ryan. (Author's collection.)

Mary Wencko is at her desk, around 1928, in St. Dominic's School in Oyster Bay. Many Syosset Catholics chose to have their children educated there from kindergarten through high school. Syosset offered no elementary and middle school Catholic education for both sexes until St. Edward's opened its doors in 1962. (Courtesy of Florence Kwiatkowski Sendrowski.)

| IF STAMPED ARREARS BELOW APPLY TO COUNTY TREASURER MINEOLA, N. Y. FOR INFORMATION AND BILLS | | ASSESSED VALUATION | | TOTAL TAX |
|---|---|---|---|---|
| | | *630* | | *4 85* |
| As of September 1, 1944 | | Pay only this amount if tax for entire year is paid on or before November 10, 1944 ☞ | | *4 85* |

SEE OTHER SIDE FOR RATES

## 1944-45
### SCHOOL TAX

### NOTE

The Section, Block and Lot Numbers on the lower part of this bill is the description of property as shown on the 1944-45 School Assessment Rolls. When writing for information or bills refer to this Section, Block and Lot.

STANLEY KWIATKOWSKI UX
SPLIT ROCK RD.
SYOSSET N.Y.

SCHOOL DIST.
| 14 | 1 2 3 10 29 38 | 534 |

EASTWOOD 1
LOTS 101-104 INC
SEC 15 BLK 25 LOTS 101-104 **INC**

| RECEIVED PAYMENT -- SECOND HALF OR TOTAL TAX VALID ONLY WHEN RECEIPTED BY MACHINE | | | RECEIVED PAYMENT -- FIRST HALF VALID ONLY WHEN RECEIPTED BY MACHINE | | |
|---|---|---|---|---|---|
| RECEIPT NO. | DATE PAID | AMOUNT PAID | RECEIPT NO. | DATE PAID | AMOUNT PAID |
| 1 8 1 5 | OCT 1 0 44 | 4.85 TAX | | | |
| CASH | CERT. CHECK OR M.O. | CHECK SUBJECT TO COLL. | CASH | CERT. CHECK OR M.O. | CHECK SUBJECT TO COLL. |

School tax in Locust Grove District No. 14 was 77¢ per $100 of assessed property for the year 1944–1945. Stanley Kwiatkowski paid $4.85 in school tax that year as owner of "lot Eastwood 1." (Courtesy of Florence Kwiatkowski Sendrowski.)

According to an 1873 map, Locust Grove School, District No. 14, was located on a corner of the William Willits property, which later became Underhill Boulevard and Jericho Turnpike. In a 1906 map, it was still there. By 1914, school No. 14 was located at what later became James Street and South Oyster Bay Road. Robin Boslet is shown, 1945, in front of the third, and last, Locust Grove School on Humphrey Drive. It replaced the older school in 1932 and was closed in the late 1970s. (Author's collection.)

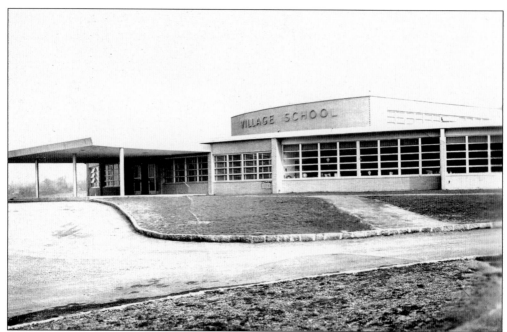

The Village elementary school, 90 Convent Road, opened in September 1954 accommodating grades kindergarten through 8. William Kupec was the principal. Very close to the center of town, it was appropriately named. The school held two eighth-grade graduation ceremonies in 1955 and 1956 before the Syosset Junior-Senior High School was established. After 1956, the school housed kindergarten to sixth grade, and with the advent of middle schools, it ended with fifth grade. (Author's collection.)

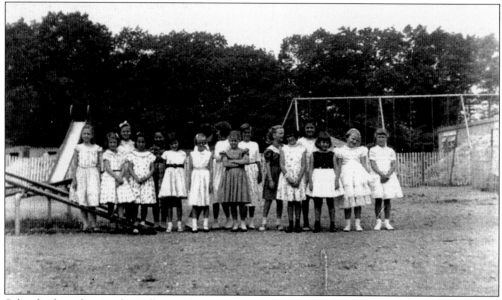

Schoolgirls gather in the Village School playground around 1956. The school was built on the hilly former site of the George Mann farm. At first, the grounds were rocky with sparse vegetation and included only basic playground equipment. In time, the rough exterior gave way to lush grassland and playing fields. Equipment was consistently updated. (Courtesy of Priscilla King.)

The School Safety Patrol was started by the AAA in 1920. The Village School formed a local chapter in 1954. Older children, wearing the white Sam Browne belt and badges designating captain, sergeant, or patrolman, helped the younger ones cross the streets near the school. Former School Safety Patrol members include 21 astronauts, Presidents Jimmy Carter and Bill Clinton, and the author, pictured in front of his home in 1955. (Author's collection.)

Syosset students attended other local high schools before the establishment of Syosset High School. It was not a hard and fast rule, but boys tended to favor Oyster Bay while the girls found Hicksville easier to reach. Students from Syosset are in the cast of this play performed at Hicksville High School, around 1932, including Stella and Nellie Nowak, standing fifth and seventeenth from left, respectively. (Author's collection.)

Syosset High School was established in 1955. For the first year, the school consisted of the ninth grade only. Classes were held at the Woodbury Elementary School while the high school on South Woods Road was under construction. (Courtesy of Priscilla King.)

In the fall of 1956, the Syosset Junior-Senior High School opened with grades 7 through 10, and, in the fall of 1958, grades 7 through 12 were active. Above is the entrance to the auditorium. The South Woods Junior High commenced in the fall of 1959 for grades 7 and 8. Syosset High School then became a four-year school. (Courtesy of Priscilla King.)

This is the sparkling new lobby in 1956. The junior prom for the class of 1960 was held there on May 2, 1959. The attendance was 260, including 18 faculty guests. It seems impossible for this room to hold such a crowd. Perhaps some outdoor activity was involved. (Courtesy of Priscilla King.)

Eighth-grader Meg Glueck is boarding the school bus on one of its first trips to the new school in the fall of 1956. It is nearly empty at this point but will fill up as it heads down Convent Road to Jackson Avenue and through the village. (Courtesy of Priscilla King.)

Leonard Cedar, pictured above in his classroom in 1957, taught ninth-grade social studies. He presented first-half-of-the-20th-century world and American history and current events. He introduced many students for the first time to the 1954 pivotal Supreme Court decision on school integration as well as to the horrors of the Holocaust and World War II concentration camps. (Courtesy of Priscilla King.)

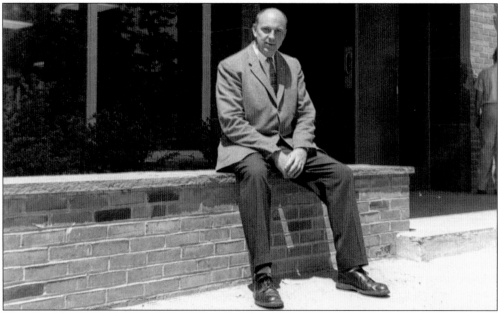

William Kupec, shown in 1957, settled in Syosset in 1948. First a teacher, he became principal of five Syosset Schools, including Syosset High School. After his retirement, he became involved with volunteer intercultural activities. His wife, Helen, remained active in the St. Edward's church. Their sons Matt and Chris, of the seven Kupec children, were star quarterbacks at Syosset High School, and their North Carolina college football cards are big sellers on eBay. (Courtesy of Priscilla King.)

*First Annual Graduation Exercises*

*Class of 1959*

*Syosset High School*

*High School Gymnasium*

*2:00 P.M. - Sunday, June 21, 1959*

*Admit One*          *Reserved Section*

The first Syosset High School graduation exercises were held in the gymnasium, June 21, 1959, as this admission ticket shows. There were 153 graduates listed on the program. There would have been more, but some students were already enrolled in other high schools and did not wish to transfer. One graduate, Kenneth George, postponed college to take more elective classes with the 1960 graduates because he enjoyed his experience so much. (Courtesy of Lynne De Rosa.)

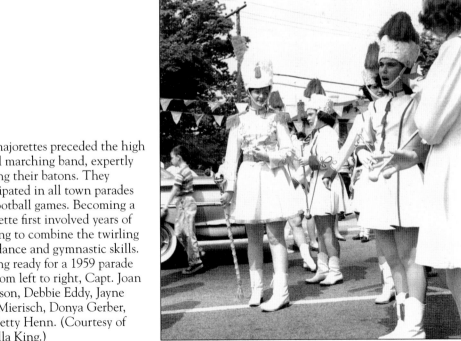

The majorettes preceded the high school marching band, expertly twirling their batons. They participated in all town parades and football games. Becoming a majorette first involved years of training to combine the twirling with dance and gymnastic skills. Getting ready for a 1959 parade are, from left to right, Capt. Joan Morrison, Debbie Eddy, Jayne Ann Mierisch, Donya Gerber, and Betty Henn. (Courtesy of Priscilla King.)

121

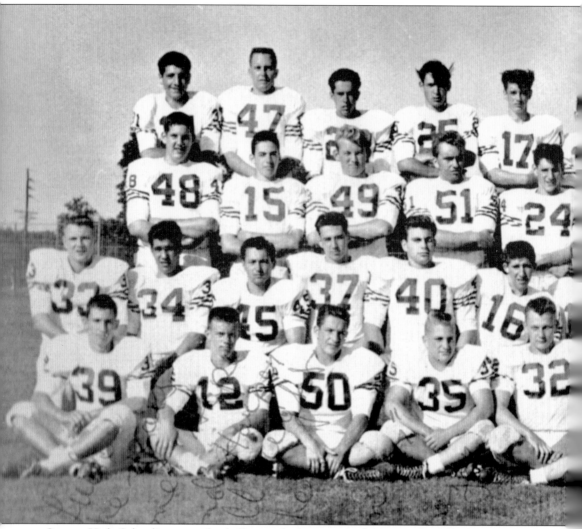

Syosset High School's varsity football team had a record of 5-2-1 in the fall of 1959. This is a picture of the combined freshman, junior varsity, and varsity teams. From left to right are (first row) Dennis Wolownik (end), Jack Erickson (quarterback), Larry Gorman (tackle), Russell

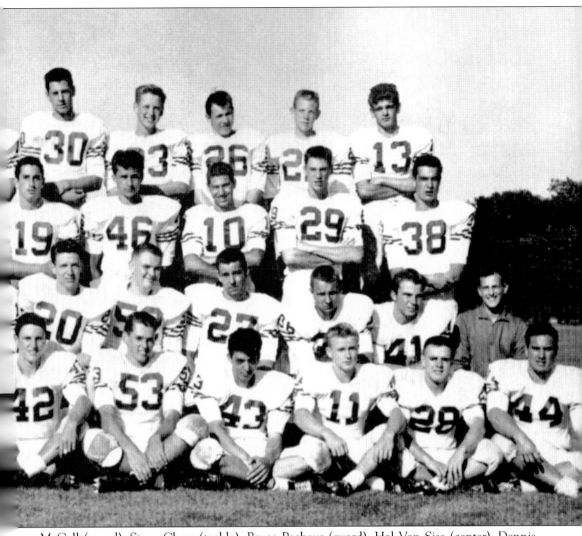

McCall (guard), Steve Chess (tackle), Bruce Pecheur (guard), Hal Van Sise (center), Dennis Gaita (end), William Eaton (halfback), Tom Bolk (halfback), and William Hogue (fullback and captain). Clark Grey (end) is on the far left, second row. (Author's collection.)

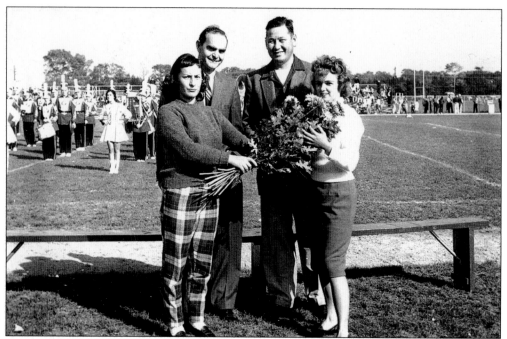

Syosset High School's sports teams were called the Braves. In the fall of 1959, an "Indian Princess" contest was held. Dr. William French, principal (left), and Stephen C. Chess, president of the Syosset Football Braves Men's Club, look on as the chosen Indian Princesses, Barbara Vallary (left), first, and Shirlee Sarver, second, share a flower bouquet. (Courtesy of Priscilla King.)

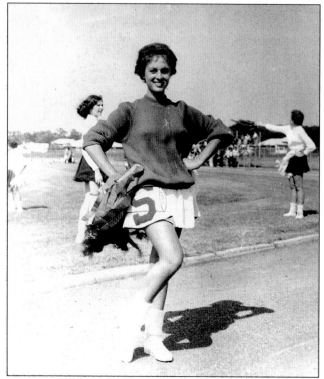

Arleen Luma of the class of 1960 was an honor student and athlete and was voted "Most All-Around" by her peer students. She was also the varsity cheerleader captain for three years. She poses on the football field in the fall of 1959. (Courtesy of Priscilla King.)

Students looked forward to the annual senior trip to Washington, D.C. The five-day itinerary included a visit to Gettysburg, Pennsylvania, a stop off in Baltimore, tours of the nation's capital including the monuments, National Gallery of Art, and the Smithsonian Institute, plus a moonlight boat ride along the Potomac River. Loretta Miller and Marie Manning are pictured at the National Gallery of Art in 1960. (Courtesy of Marie Manning.)

Geraldine "Gerry" Horan is contemplating a rose at her class of 1962's senior prom, which was held in the gymnasium. Her date was her future husband, Richard De Asla, a 1960 graduate. A typical senior prom in the early 1960s was held in the gym with dancing and refreshments from 9:00 p.m. to midnight, with maybe a stop at Carl Hoppl's nightclub in Baldwin afterwards. (Courtesy of Richard De Asla.)

Judy Prianti is the daughter of the late Dominick Riccoboni, a former chief of the Syosset-Woodbury Fire Department. She graduated from Syosset High School in 1962. Prianti became an actor and producer, a member of the Screen Actors Guild, the American Federation of Television and Radio Artists, the Guild of Italian-American Actors, and the Actors' Equity Association. She has had many roles in Hollywood and independent motion pictures. She had a principal role in the television series *The Sopranos* as Connie Fazio. (Courtesy of Judy Prianti.)

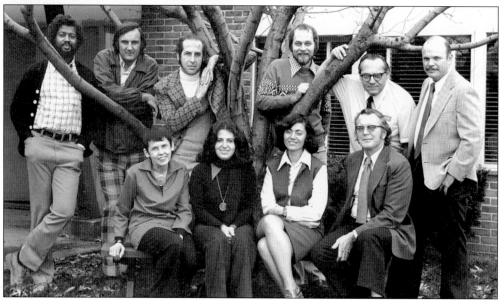

The Art Department started in the beginning with a small but dedicated staff of three: Lynne De Rosa, Jean Mitchell, and chairman John Price. A much larger department is pictured outside the school in 1975. From left to right are (first row) Lynne De Rosa, Peggy Ross, Valerie Holmes, and John Black, chairman; (second row) Reginald Fludd, John Kozusko, Barry Lieberman, Paul Ratajczak, Lennie Herman, and Hartley Meinzer. De Rosa retired in 1982 after being the mainstay of the Art Department for 24 years. De Rosa, Fludd, and the late Black are noted American artists. (Courtesy of Lynne De Rosa.)

Nancy and Ronald G. Barry (1935–2006) are shown on vacation in Ireland, in the 1990s. Nancy Glennan, a Syosset resident, taught French at Syosset High School in the late 1950s and early 1960s. She and Ronald were married in 1962. Not much older than his students, Ronald taught English there beginning in 1957. He spent the next 42 years as teacher, dean, and assistant principal. He held the latter position for more than 20 years. He was the faculty advisor to the student newspaper, the *Pulse*, throughout his career. More than 200 former students honored him at his retirement party at the Woodbury Country Club in 1999. There would have been countless more had there been enough room. Ronald's positive caring impact on his students' lives is his legacy to them. In the 19th century, the LIRR drew people to the old hamlet of Eastwoods. In the 21st century, many people have come to live in Syosset because of its fine school system, because of educators like Ronald, who pioneered its excellence. (Courtesy of Nancy Barry.)

# ACROSS AMERICA, PEOPLE ARE DISCOVERING SOMETHING WONDERFUL. *THEIR HERITAGE.*

Arcadia Publishing is the leading local history publisher in the United States. With more than 3,000 titles in print and hundreds of new titles released every year, Arcadia has extensive specialized experience chronicling the history of communities and celebrating America's hidden stories, bringing to life the people, places, and events from the past. To discover the history of other communities across the nation, please visit:

# www.arcadiapublishing.com

Customized search tools allow you to find regional history books about the town where you grew up, the cities where your friends and family live, the town where your parents met, or even that retirement spot you've been dreaming about.